BETTER PICTURE GUIDE TO
Lowlight
Photography

RotoVision

A RotoVision Book
Published and Distributed by RotoVision SA
Rue Du Bugnon 7
1299 Crans-Près-Céligny
Switzerland

RotoVision SA, Sales & Production Office
Sheridan House, 112/116A Western Road
Hove, East Sussex BN3 1DD, UK

Tel: +44 (0) 1273 72 72 68
Fax: +44 (0) 1273 72 72 69
E-mail: sales@RotoVision.com

Distributed to the trade in the United States by:
Watson-Guptill Publications
1515 Broadway
New York, NY 10036
USA

10 9 8 7 6 5 4 3 2 1

ISBN 2-88046-512-5

Book design by Brenda Dermody

Production and separations in Singapore by ProVision Pte. Ltd.
Tel: +65 334 7720
Fax: +65 334 7721

BETTER PICTURE GUIDE TO

Lowlight
Photography

DAVID DAYE

Contents

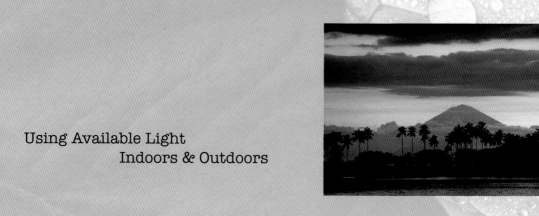

Using Available Light
Indoors & Outdoors

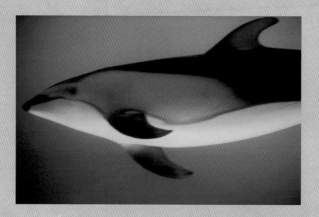

1

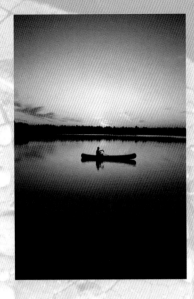

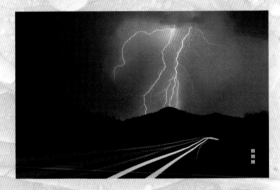

Photographers will always come across situations where the subject or scene is ideal but the lighting is not. Using flash would destroy the visual effect or make the colours of a portrait subject too bright. In such conditions photographers have to make the most of the lighting that is available, whether that lighting is good or bad. Often the lighting is bad yet it's possible even in these conditions to create an eye-catching image that's full of impact, as these examples will show.

Sunsets

A sunset is a spectacular and popular subject full of photographic potential. Although it involves photographing a light-source itself, the lighting conditions can vary; and the exposure requirements will depend on the effect the photographer wishes to achieve.

Seeing

The most popular sunset image includes the sun itself, its vivid brightness making it the focal point of the composition. It produces an effective image when photographed with a geographical or man-made object, which also helps to give a sense of scale.

Thinking

A sunset reflected in the sea or a lake gives the image additional visual interest. The sun provides the actual illumination by which it is photographed so the lower it is in the sky, the less light will be available.

Acting

A straight exposure reading taken from the bright areas (though for safety's sake, not the sun itself) or a midtone would reproduce the sun as a strong orange disc, but the rest of the scene would be dark. Increasing the exposure, by using a slower shutter speed or a wider aperture has made the sun more yellow and brighter, and has provided more visible detail in the rest of the image.

Rule of Thumb

Just after the sun has dropped below the horizon it leaves an after-glow, an area of brightness that remains in the sky for a short while. In clear conditions this provides a large area of graduated colour that can be used as a background for striking silhouettes or semi-silhouettes.

Technical Details 35mm SLR camera with a 28–85mm zoom lens set to 85mm focal length and Kodachrome 200.

A low sun and water form the elements of a classic sunset photograph. The sun is the focal point of the image and determines whether the format is vertical or horizontal.

Technical Details 35mm SLR camera with a 50mm lens and Fujichrome.

Seeing

A sunset can totally transform any location, even one that, when seen in ordinary daylight, might not seem to have many possibilities. The travelling photographer has access to many such scenes that can be used as a background or as the main part of an image.

Thinking

The photographer knew where the Western sky was, and anticipated how the setting sun would affect this scene. And he knew that any shapes – here it's the palm trees – would form a silhouette when placed against a sunset sky.

Acting

The photographer's use of a moderate telephoto lens has created the impression that the distant mountain is closer to the trees than it really is. And the placement of the silhouetted trees at just below the central area has resulted in a good visual balance between the sea and the sky.

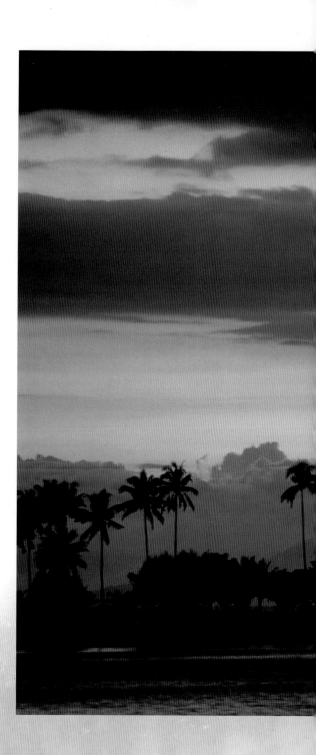

Sunsets

Seeing

A standard sunset image can have plenty of visual impact, though if there is little variation then this type of image can become repetitive. Look for those precious moments after the sun has set. They can provide many opportunities to create a picture that is full of mood and atmosphere.

Thinking

Large areas of water can form a powerful element in any photographic composition, because they are able to reflect the sky and objects around them. The mirror effect can be especially striking when used to include the warm colours of a sunset sky.

Acting

The different elements in this composition needed careful positioning to create a balanced image. In the viewfinder the photographer positioned the boat to occupy one third of the image width. This showed a large expanse of the mauve and purple colours that have such strong impact in this tranquil scene.

Sunsets don't always occur in ideal conditions. Clouds can hide all or most of a sunset, yet moments like this can result when the sun's illumination passes through gaps in the clouds. The contrast between the sun's reflected light on the waves and the dark surrounding areas has created a moody, dramatic image.

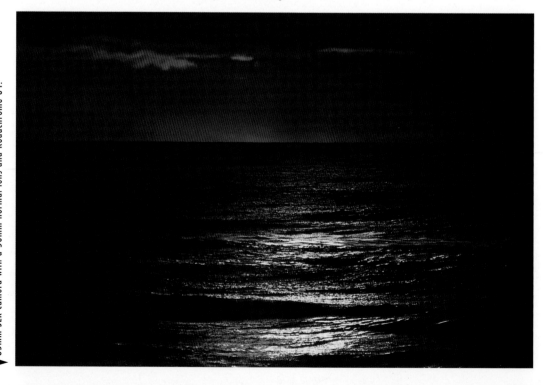

Technical Details
35mm SLR camera with a 50mm normal lens and Kodachrome 64.

Technical Details

35mm SLR camera with a 35–70mm zoom lens set to 40mm focal length and Kodachrome 64.

Lightning

Lightning is an untamed force of nature that demands respect and patience from the lowlight photographer. Awareness of personal safety comes first, and all necessary precautions should be taken to ensure safe shooting. By using well thought-out techniques and advance planning a photographer can produce some stunning images of this spectacular subject.

Seeing

A thunderstorm is the normal environment in which lightning occurs. But it is impossible to accurately predict where lightning will strike, and exactly where it will appear in the frame.

Thinking

A suitable skyline has been chosen, and the framing has left plenty of space for the lightning to appear in.
The type of film used by the photographer will depend on whether a smooth-grained image (using a slow film speed of ISO 25, 50 or 64) or a coarse-grained image (a fast film of ISO 200 or 400 or higher) is required.

Acting

The B setting enables the shutter to stay open for several seconds, minutes or even hours. This increases the chance of capturing a lightning bolt or several of them. But the photographer needs to limit the amount of time the shutter stays open for. The longer it stays open the brighter the image will become. This will reduce the contrast between the lightning and dark surroundings and therefore the impact.
Several shots were taken to increase the chances of getting the right one. And because the B setting was being used the camera was mounted on a tripod.

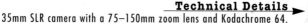

Technical Details ▶
35mm SLR camera with a 75–150mm zoom lens and Kodachrome 64.

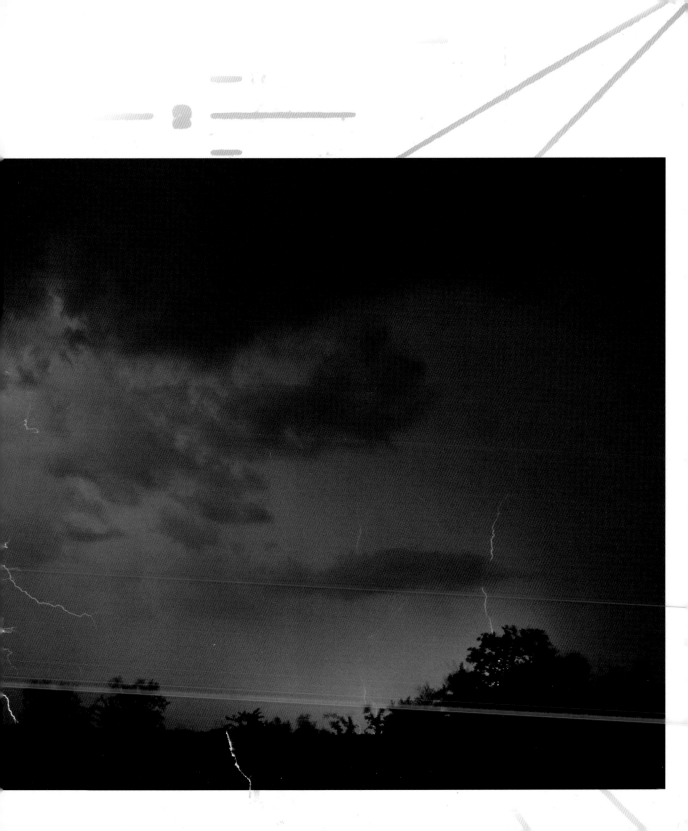

Lightning

Lightning over a city skyline combines artificial illumination with that of nature to produce a dramatic result.

Seeing

A city skyline is a great setting for lightning photography. Night-time or very lowlight conditions are obviously the best as they provide a dramatic composition with high contrast.

Thinking

A bolt of lightning happens in the smallest fractions of a second. The slower the shutter speed the better the chances of capturing a lightning streak on film.

The photographer knew that the long exposure, using the B setting, would capture more than one lightning bolt.

Acting

The safest place to photograph lightning from is inside a building which has suitable lightning conductors. A high building provides a safe shooting position as well as a raised viewpoint, making composition easier. The camera was placed on a tripod to guarantee a sharp image.

A cable release was used to press the shutter button without the photographer needing to touch the camera itself. This procedure reduces the risk of shaking the camera which would cause a blurred image.

Technical Details

35mm SLR camera with a 70–210mm zoom lens set to 100mm focal length and Kodachrome 200.

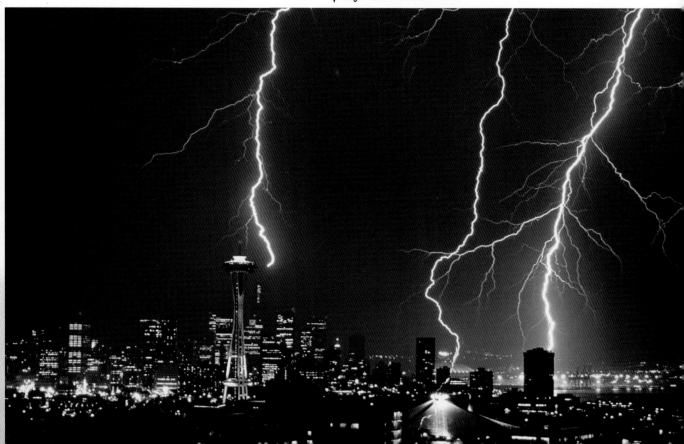

35mm SLR camera with a 85mm short telephoto lens and Fujichrome 100 colour slide film.

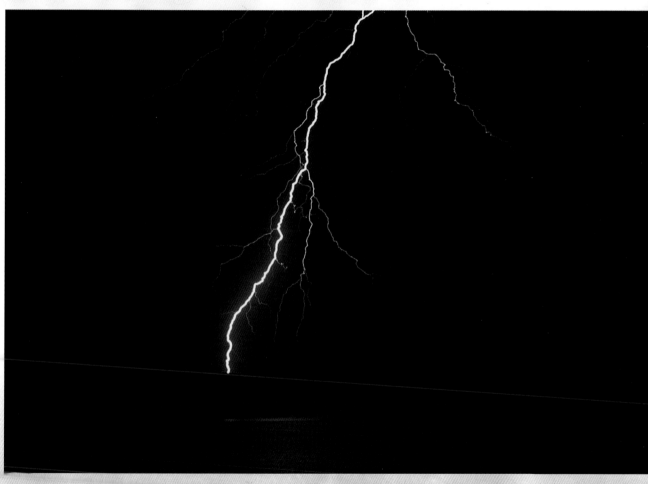

It's easy to forget the composition when preparing to photograph lightning. Framing such a subject is difficult as the photographer has to allow for the space that the expected lightning bolts will take up in the image.

What is guaranteed is that a lightning bolt will be the focal point of your composition.

Lightning

Seeing

A good photograph, no matter how spontaneous it might appear, will benefit from advance planning. Knowing what the lighting conditions are likely to be, finding the right location then setting up for the shot, all contribute to the success of an image as much as good composition.

Thinking

The photographer wanted to take more than just another image of lightning. As a photographer with experience in lowlight work he knew that, given the right conditions, such an image was possible but needed to be worked out in some detail.

Acting

Lightning is best photographed using the B setting, which gives an unlimited exposure time. The B setting is also perfect for photographing car light trails, which require a long exposure. The photographer has effectively captured both subjects on the same frame. It took good composition, timing, plus patience and several frames to produce this wonderful image.

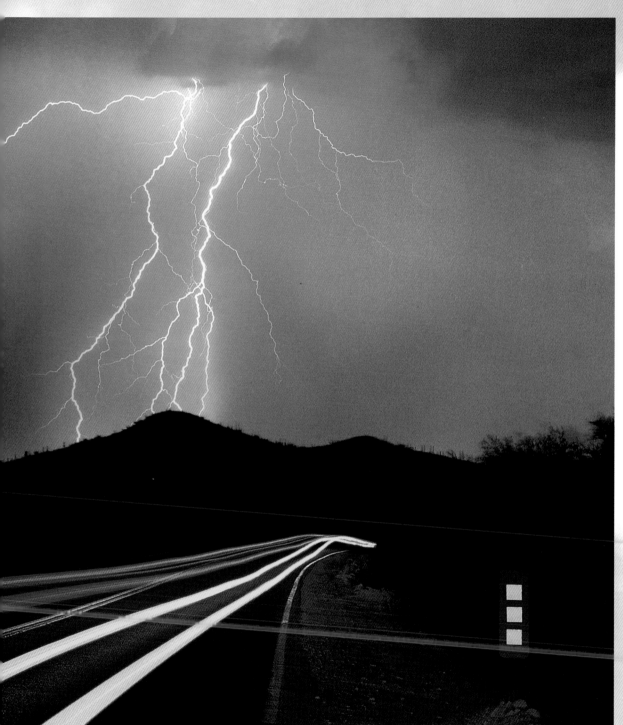

Technical Details

35mm SLR camera with a 28–70mm zoom lens set to 28mm focal length and Kodachrome 64.

Moon & Stars

The moon is a natural light-source, and is a popular subject for night photography. It can be the main subject itself, or it can be photographed with a skyline or a silhouette, or as a night-time subject lit by its own illumination.

Technical Details

35mm SLR camera with a 200mm telephoto lens. Fujichrome 100 was rated at ISO 400 to improve exposure flexibility, by providing a faster shutter speed and/or a small aperture.

The beautiful shape of the crescent moon is the focal point of this image. The photographer used a telephoto lens to produce a large image of the moon, while the clouds and darkness form a suitable background.

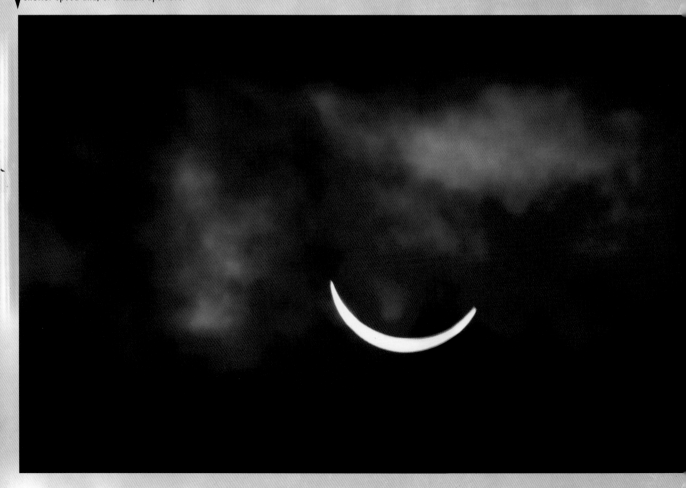

Seeing

The moon is often set against a **background** that complements its bright distinctive shape. The photographer knew that the sky in this image, halfway between **evening** and night, would be the perfect setting.

Thinking

The beautiful shape of the crescent moon is enough to fill the top part of the frame, though a **silhouetted** skyline at the base of the image gives extra interest to the composition and a sense of balance.

Acting

Shake-free shots can be achieved using a fast film and the right lighting situation but in conditions as **dark** as these a tripod is a must. As well as ensuring a steady camera a tripod also helped to keep the horizon straight.

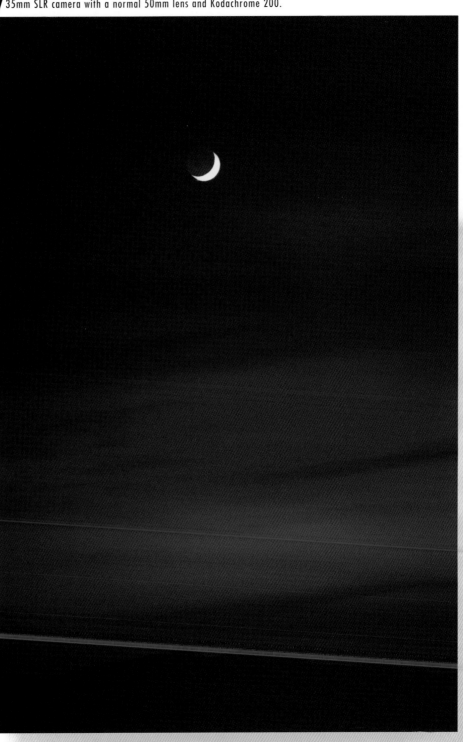

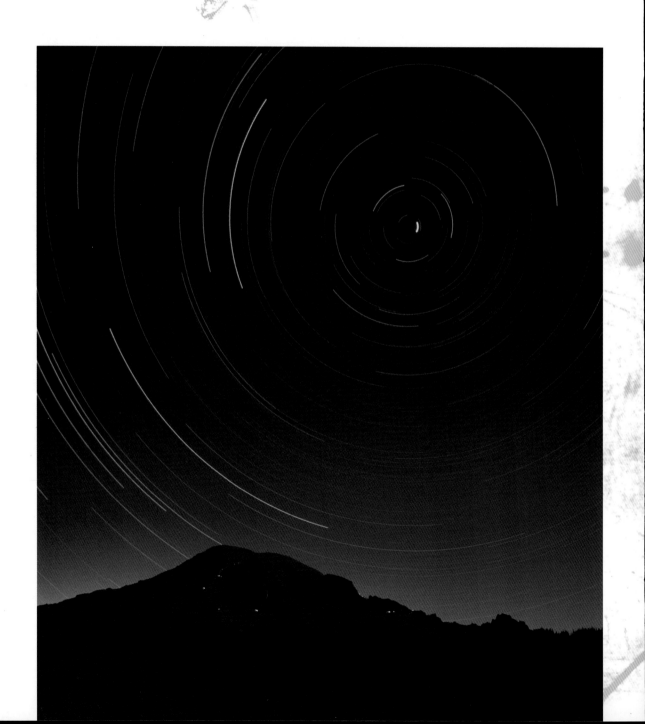

Seeing

A starry sky provided several pinpoints of light but lacked a main area of interest or a sense of composition. The photographer knew that placing a silhouetted skyline at the base of the image would give a balanced picture, one that is easier on the eye yet doesn't weaken the impact of the stars.

Thinking

The exposure needs to be chosen carefully, as too slow a shutter speed will record the stars' movement across the sky and result in streaks instead of just pinpoints of light. As with moon photography, a tripod is essential.

Acting

The image was framed so that the silhouette area takes up the lower third of the picture. The precise framing allowed the rest of the image area to be filled with stars.

Absolute steadiness was needed for this shot, so the camera was mounted on a tripod and a cable release was used.

A photograph of stars in the sky showing light streaks denoting movement. This was caused by a long exposure of around 1 hour combined with the earth's rotation.

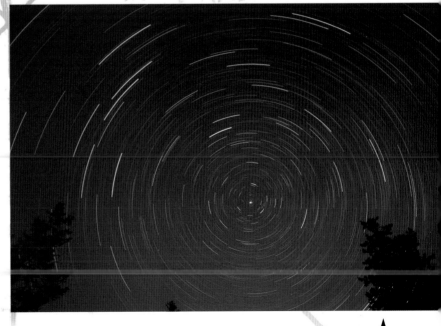

Technical Details
35mm SLR Camera with a 85mm short telephoto or 'portrait' lens and Kodachrome 64.

Technical Details
35mm SLR Camera with a 50mm lens and Kodak Ektachrome 20.

Low Daylight

A lighting situation that might first seem very difficult or even impossible to photograph can be solved by using the B setting. With the unlimited shutter speeds available to the B setting the photographer can capture any image even if it is in total darkness. Naturally, with exposures that may last several minutes the photographer will need to accept some limitations, such as the fact that any movement will register as a blur, and that the capability of the film to be able to record colours accurately will be seriously affected.

Rule of Thumb

Reciprocity Law Failure

Films are designed to work within a limited range of exposure settings. Going beyond this range causes a film's colour accuracy to be affected. This condition is called Reciprocity Law Failure.

For photographers who wish to maintain accuracy in this situation the way to do this is by using special colour correction filters. However, some of the colour inaccuracies caused by Reciprocity Law Failure can enhance an image. Many photographers choose to retain these colour changes, using them as part of the composition.

Seeing

The photographer decided to capture this subject while on a canal boat journey. The shot was composed so that the boat in the foreground became the focal point.

Thinking

Such a scene demands a tripod, use of the B setting, and some experience of assessing and photographing subjects in extremely low lighting.

Acting

A built-in SLR meter was used to calculate the exposure and the photographer used this as a basis for the final exposure, which lasted for about 3 minutes. And a flashgun on its auto setting was positioned off-camera and pointed at the boat to provide fill-in flash.

Rule of Thumb

When photographing using the B setting it's not always necessary to have a film with a high ISO speed, because the camera will be tripod-mounted so there's little chance of the camera being jogged during the exposure.

The photographer took this image from a low viewpoint so as to tightly link the foreground and background elements.

Technical Details

35mm SLR camera with a 35–70mm zoom lens set at 35mm focal length and Fujichrome Provia.

▼

Low Level Lighting

Photographing in the shade or in full shadow when other parts of a scene are bright is an uncommon lowlight problem. Exposure needs to be carefully judged in order to maintain a particular lighting effect or atmosphere and to control contrast.

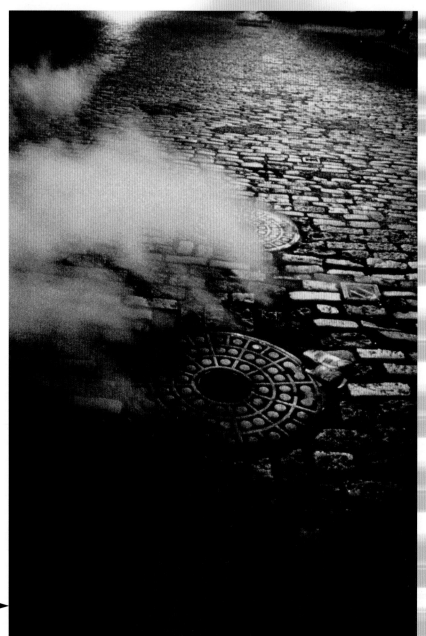

Seeing

The lower the viewpoint the more dramatic an image appears. The steam rising from the manhole cover adds a touch of life to this streetlight scene.

Thinking

A night-time scene such as this has instant drama and impact. Here the photographer knew the effect would be enhanced by the strong contrast between light and dark areas.

Acting

A wide-angle lens used in the vertical format has produced a foreground area that leads the viewer's eye into the image. The photographer was careful to avoid any artificial light including actual light-sources, although their beams of illumination and reflections on shiny surfaces are clearly evident.

Technical Details ►
35mm SLR camera with a 35mm lens and Ilford HP5.

Technical Details
35mm SLR camera with a 28–70mm zoom lens set at 35mm focal length and Fujichrome 100.

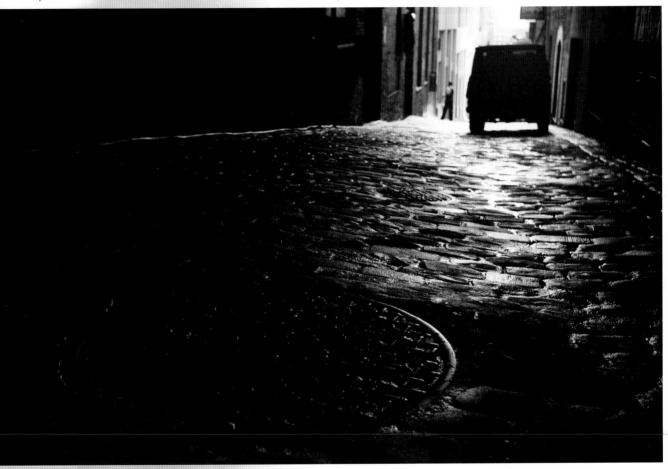

Once again, a low viewpoint has given a dramatic perspective in a street scene similar to the one opposite. This time the picture was taken in daylight although the shadowy conditions required lowlight photography skills. Notice how even the smallest shiny surfaces have been able to show textural details as they have picked up illumination from the distant light source.

Low Level Lighting

Many larger aquariums and sea aquariums have pools with all-round viewing facilities. Interior viewing facilities are often generous and on bright days there is sufficient existing light for photography.

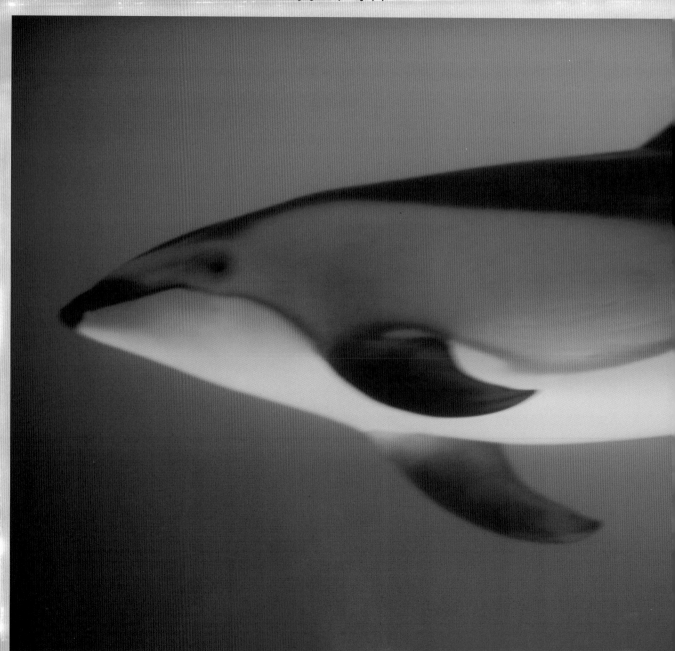

Seeing

Dolphins are one of the most photogenic and easily photographed of all sea creatures. In an aquarium environment such as this there is easy access to them, and there are opportunities for good images even with the most basic of photographic equipment.

Thinking

Water in sea aquariums is kept constantly clean and free from debris, providing a clean background for your subjects. The blue coloration often occurs when shooting in these conditions using daylight (i.e. normal) film. If required, special filters can be used to compensate for or reduce the colour cast, though some photographers prefer the effect of the un-filtered image.

Acting

It's possible to take photographs through thick plate glass and get acceptable results. Flash can be a problem here as it might be forbidden and it could cause an unwelcome reflection off the glass surface. An alternative is a fast film with an ISO speed of 200 or higher, giving access to a range of shutter speeds that will be fast enough to freeze movement.

For this image anticipation was a key factor. The photographer knew what the dolphin's route would be, positioned himself accordingly, and then waited patiently for his subject to appear. This was one of several shots.

Technical Details
35mm SLR camera with a 28–70mm zoom lens and Fujichrome 400. ▼

Abstract

When used creatively lowlight can be made to work in the photographer's favour. It gives access to as wide a range of subject-matter as in normal photography, including the creation of abstract or semi-abstract images.

Seeing

A small detail may often be the first item that attracts a photographer's **attention** to a scene or subject. The detail may then form part of the whole **composition** or may be visually interesting enough to exist as an image by itself.

Thinking

Red and black is a dramatic **combination** of colours. Red reflected on water produces an image that is vivid with plenty of visual impact. Even though red is such a vibrant colour, when it is combined with the **lowlighting** and dark areas, as in this image, it helps to produce an effect that is tranquil.

Acting

A telephoto or zoom lens was used to isolate this area from an overall scene, separating it from other **elements** that might have been visually distracting and weakened the **composition**.

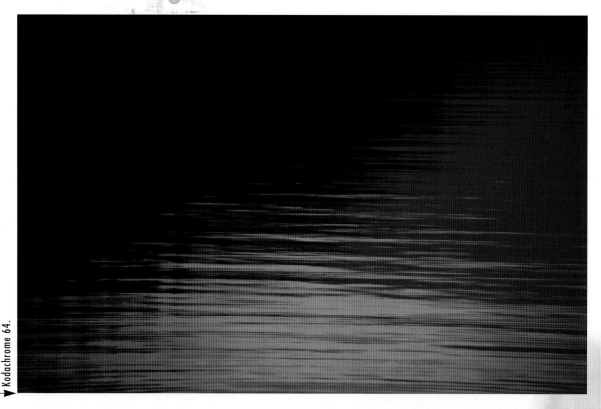

Technical Details
35mm SLR camera with a 105mm telephoto lens and Kodachrome 64.

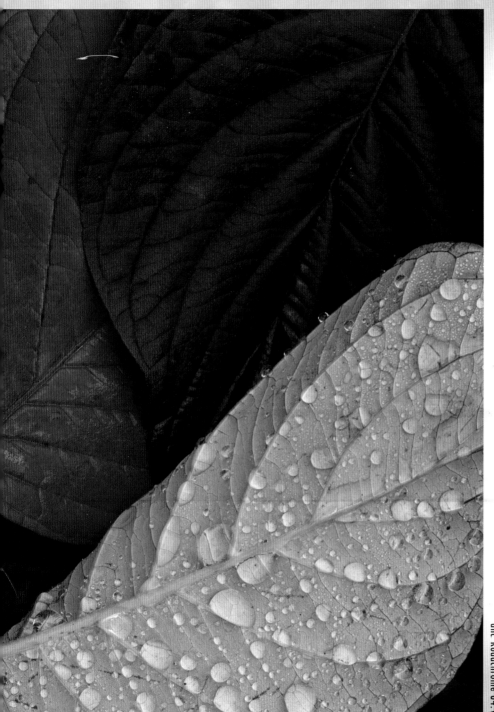

Shortening the distance between the camera and the subject, as happens in close-up work, reduces the amount of light available to the photographer. Because depth of field in these situations needs to be maximised, a very small aperture setting is required. This in turn leads to the necessity of using a very slow shutter speed. Overcoming these difficulties and coming up with a successful result can be highly rewarding.

A stable camera, a close-focusing lens and calm conditions all contributed to this sensitive leaf study.

Technical Details

35mm SLR camera with a tripod-mounted 28-70mm zoom lens and Kodachrome 64. ▼

Twilight

Twilight, the brief time between sunset and
night, can be a source of magical images.
The remaining brightness in the sky plus the right subject can be a
winning combination for the lowlight photographer.

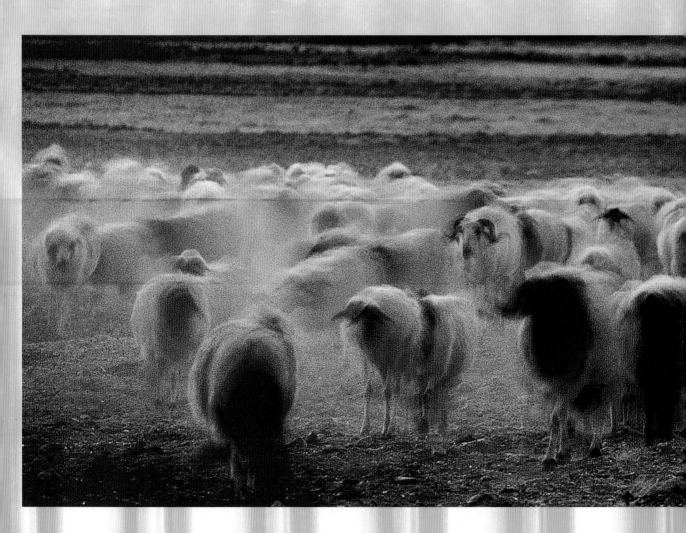

Seeing

There was just enough light in this **evening** scene to capture the shepherd with his flock. This was a grab shot, its success depending on the photographer's **reflexes** in the dwindling lighting conditions.

Thinking

It takes some skill to accurately **frame** moving subjects. Here the photographer has anticipated the action, positioning the different elements to produce a balanced **composition.**

Acting

This image was photographed using a **moderate** telephoto lens. Fast film was used because the light levels – just after sunset – were low. The grainy texture of this film type suits the soft lighting.

Technical Details

35mm SLR camera with a 200mm lens and an ISO 400 film rated at ISO 800.

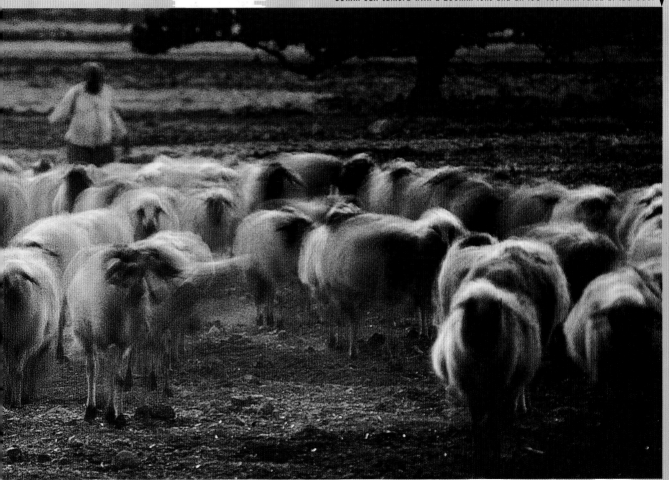

Silhouettes

In some lowlight situations it may be difficult or impossible to balance the light and the dark areas to get a good exposure. This results in a silhouette, showing only a dark outline and no surface details or colour in the subject. Because of their strong simple shapes silhouettes have plenty of visual impact, especially when combined with a complementary colour.

Technical Details
35mm SLR camera with a 24mm wide-angle lens and Kodachrome 64.

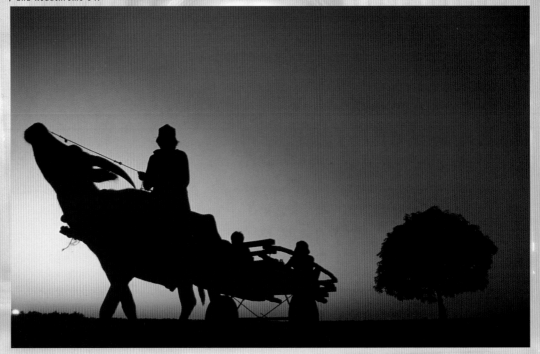

A clear sky immediately following a sunset gave a beautiful graduation of colours from red to blue. The brightness was sufficient to give a strong outline to the shape of the bullock cart in this Asian scene.

Note the tree silhouette which fills in the space at the lower right area of the frame.

Seeing

The scene was already in silhouette or near-silhouette when the photographer first considered it as a potential image. The light left in the sky just after the sun had set gave a perfect orange background on which to superimpose the silhouette.

Thinking

The photographer decided to separate just these elements from the whole scene. The dominant prow of the larger or foreground ship takes up most of the image area, yet it has been balanced by the smaller silhouette.

Acting

A long telephoto lens has isolated the two shapes from the rest of the scene. A telephoto lens gives the appearance that the area between foreground and background subjects is shorter than it actually is. Careful framing and slight under-exposure made the silhouette shapes darker without reducing the light in the rest of the scene.

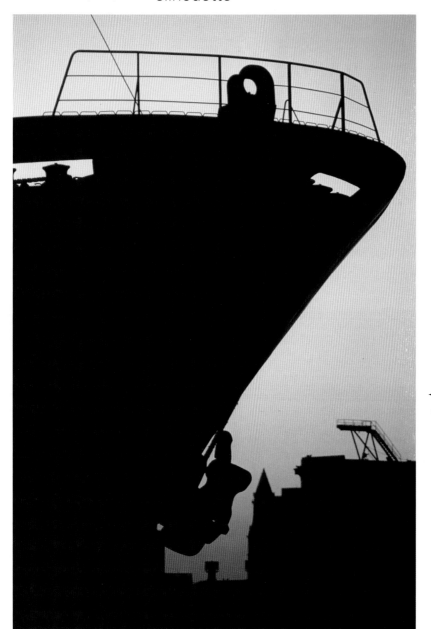

Technical Details
35mm SLR camera with a 200mm telephoto lens and Fujichrome 100.

Silhouettes

Silhouettes created by man or by man-made objects are no less difficult to compose than if they were natural silhouettes. They may appear to be more two-dimensional (i.e. as if they were a drawing) than a normal image, but the photographer still needs to work hard to successfully combine the different elements effectively.

This silhouette composition is dominated by man-made objects. The beautiful shapes of the nets are complemented by the boats and the standing figures. A bird neatly fills the space towards the top right of the scene. A telephoto lens has compressed the distance between the different elements, giving the impression that they are all on the same plane, or on one flat 'canvas'.

Technical Details
35mm SLR camera with a 70–210mm zoom lens set at 200mm focal length and Kodachrome 64.

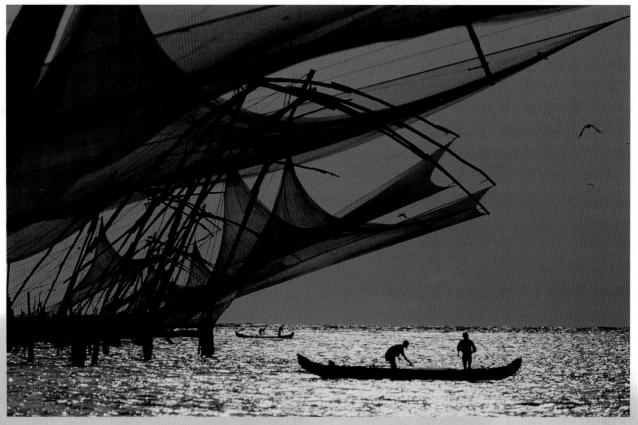

Technical Details
35mm SLR camera with 80–200mm zoom lens used at
135mm focal length. Fujichrome 100, rated at ISO 400.

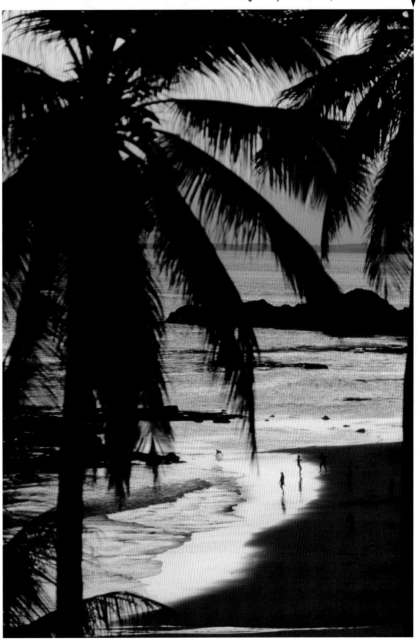

Seeing

Lowlight has a habit of completely changing the appearance of a place, making it look dramatically different to the way it would look in bright lighting. The darker conditions and the long shadows cast have given a moody feel to this beach silhouette.

Thinking

The sun is well below the horizon yet there is just enough light to allow differentiation between the light and the dark areas. The photographer used the palm trees to successfully frame the image.

Acting

The photographer has placed himself at an appropriate position to get the right framing for this picture. The exposure has been well chosen too. If it was two or more stops brighter the silhouette effect would have been less pronounced and the mood of the image would have changed.

Silhouettes

Seeing

A silhouette is an object that has been reduced to an outline. Some shapes will make better silhouettes than others. An experienced photographer will be able to quickly judge how a specific shape will make an effective silhouette.

The sky and the various colours and textures it provides is the main source of backgrounds for outdoor silhouettes.

Thinking

The aerodynamic shape of a jet plane is perfect for a silhouette, and this photographer knew that the sky with its sunset afterglow would form the ideal backdrop.

Acting

The photographer positioned the jet to fill the lower third of the frame. If it had been at the centre the visual balance of the image would have been affected, and much less of the wonderful sky colours would have been seen.

To expose for a silhouette simply take a reading from the brightest part of a scene and either use that reading to get a dark silhouette and a darker overall picture, or increase the exposure by around one to two stops. This will lighten the image, and it will make the colours appear brighter too.

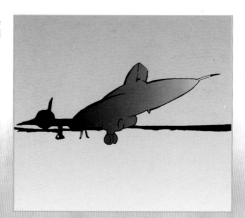

This is how the image would have looked if the horizon line had been halfway up the frame.

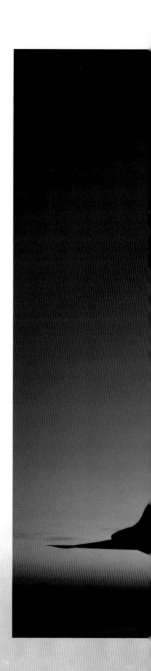

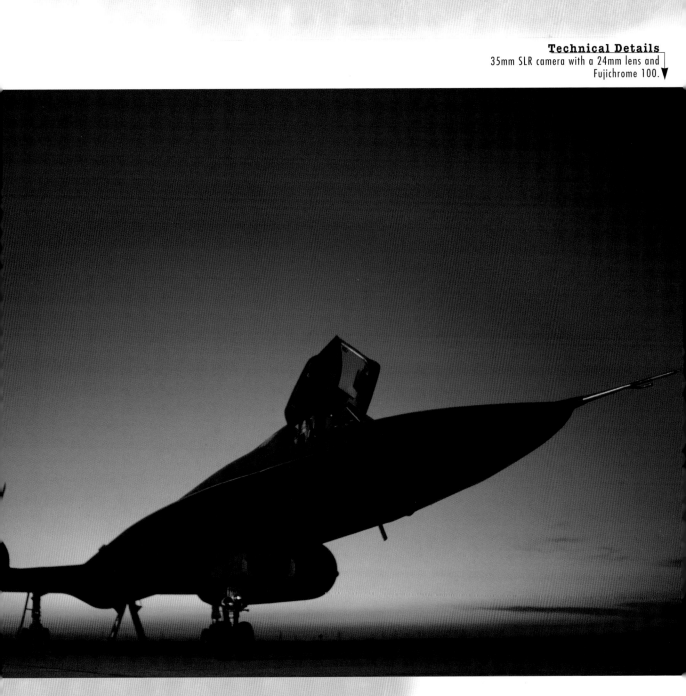

Silhouettes

Seeing

The figures and the framework of this construction site photographed against an overcast sky form a perfect silhouette image. The simple bright background enables the outlines to stand out sharply.

Thinking

The human figures give a sense of life to the scene, give the viewer information about the activity that's taking place, and also add a sense of scale.

Acting

The photographer based his exposure on a reading from the sky. In these conditions no special calculations were required, just a straight exposure reading.

The photographer took a series of shots of the two figures, deciding on this one as his final choice.

Technical Details

35mm SLR camera with a 300mm telephoto lens and Fujichrome 100.

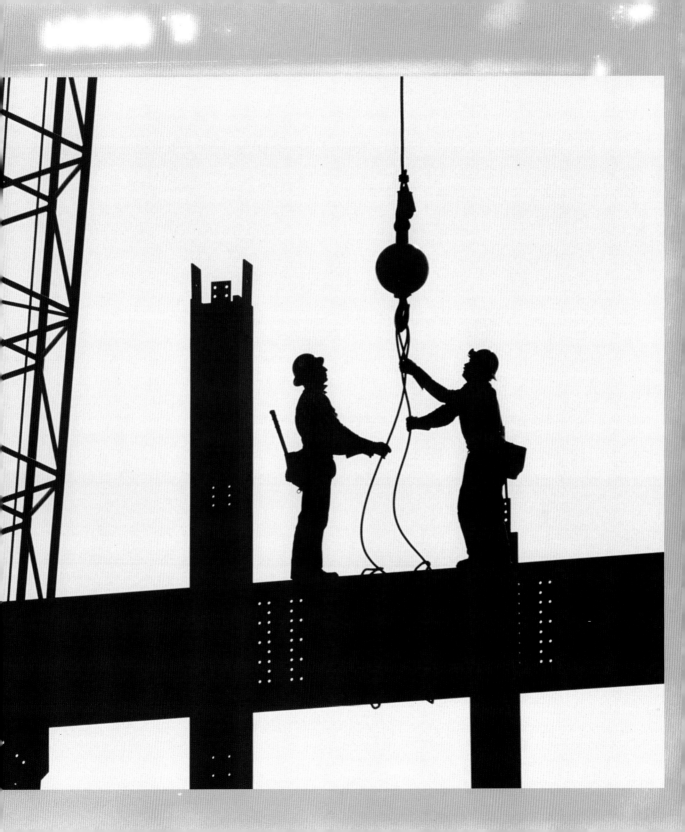

Interiors (Natural Light)

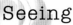

Technical Details
35mm SLR camera with a 35–70mm zoom lens and Ilford FP4 b&w
Print was treated with toning solution to get the sepia colouring.

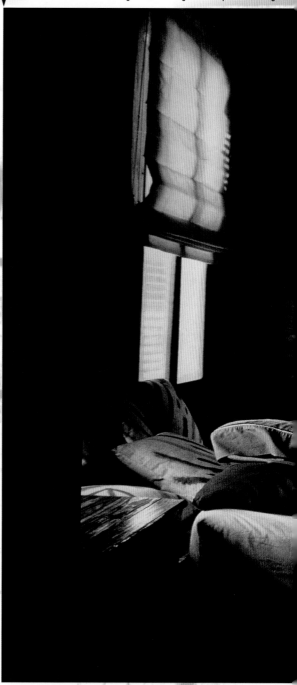

Seeing

Natural daylight pouring into a room has been the basis of so many classic images by photographers past and present. Here, its strong simple illumination, spreading evenly through the room, has been controlled and channelled by the shutters and softened by the semi-transparent curtains.

Thinking

The model's pose forms the heart of the composition and whether it was set up or not the effect looks entirely natural. The whole image gives an impression of calm, of an intimate moment that has been captured. The combination of elements gives it a timeless quality.

Acting

The faultless framing and composition contribute to the success of this image, and the camera's position played an important part. A camera mounted on a tripod is necessary in this situation, where a long exposure time is unavoidable.

The resulting image, photographed on black and white film, was then subtly sepia toned.

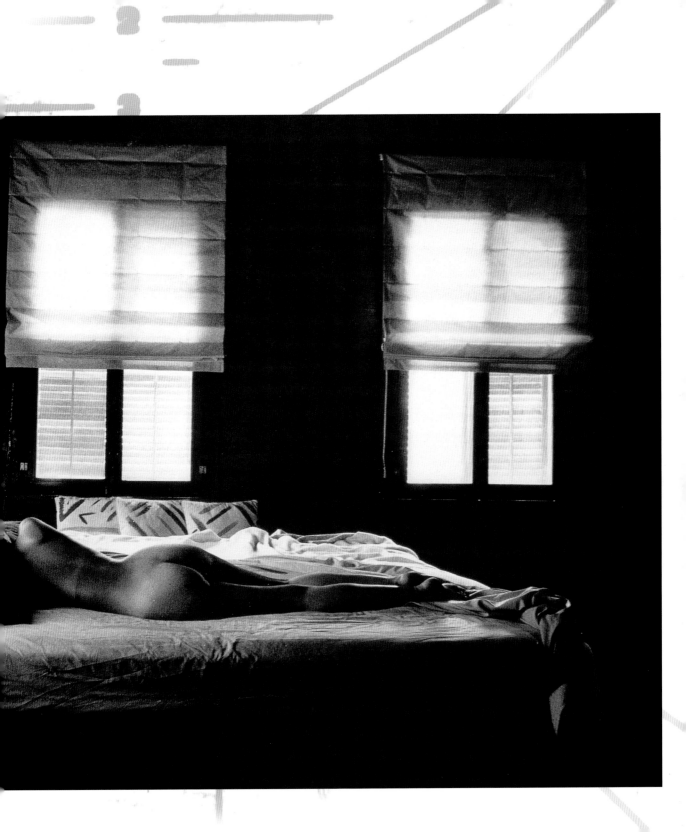

Interiors (Natural Light)

Seeing

The sun is the most powerful light-source available to the photographer. And when its illumination is at a right angle it can light up the darkest and largest interiors, as seen in this photograph taken inside a church.

The windows have let in the natural daylight which has reflected itself off all the surfaces it has come into contact with and spread its illumination throughout the interior.

Acting

With such strong lighting the exposure setting for this image had a shutter speed that enabled the camera to be used without a tripod.

A wide-angled lens was used to include a large expanse of the church interior. A bonus with a wide-angle lens is its extensive depth of field, with sharpness that extends right across the scene.

Thinking

The widespread lighting means that a flash is unnecessary. Also the available lighting has created a totally natural looking result that a flash or several flashes would be unable to accurately reproduce.

Technical Details

35mm SLR camera with a 24mm wide-angle lens and Kodak Ektachrome 100.

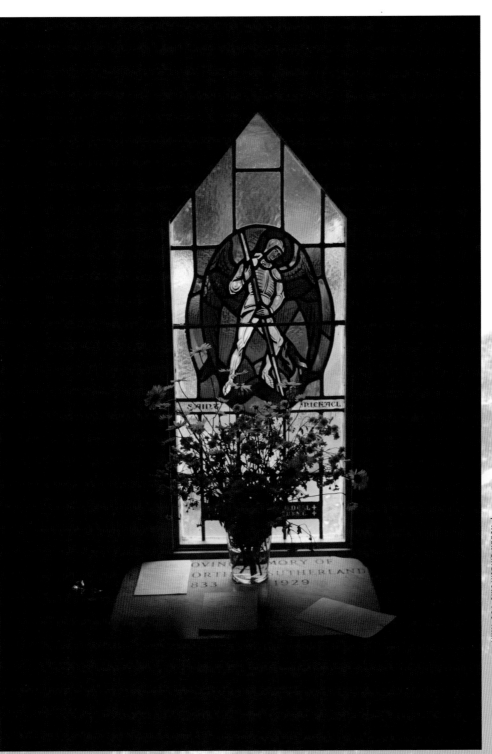

Daylight, the only light source in this image, has created a semi-silhouette because the window details and vase of flowers obstruct most of the incoming light.

Flash may have produced a brighter result, showing more detail in the subject but the mood and semi-silhouette effect would have been lost.

Technical Details
35mm SLR camera with a 50mm lens and Kodak Ektachrome 100 film.

Interiors (Natural & Artificial Light)

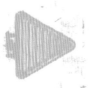

Seeing

A simple lace curtain acts like a special effects filter in this image. Light shining through it (and through the chair back) casts a pattern of shadows over the surfaces of objects, transforming the whole scene.

Thinking

The photographer composed the shot so that the lace curtain, plus the leaves that can be seen behind it, took up most of the area. The lower third has additional detail provided by the table and chair, which also give depth to the image.

Acting

The strong light source, directly from the sun itself or a strong reflection derived from it, needed to be reduced in intensity. The exposure chosen has achieved this, giving just enough detail to show the textures and shapes of the interior objects. A wide-angle focal length of 35mm or 28mm was used to frame the scene perfectly.

Technical Details

35mm SLR camera with a 35–70mm zoom lens set at 70mm focal length and Fujichrome 100.

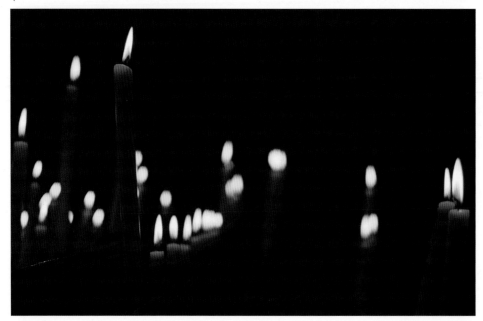

Candlelight is the only light source in this image, and candles are also the subject. When they are totally surrounded by darkness as they are here, candles create an atmosphere of peace and contemplation.

The photographer took the exposure reading from the candle flames, knowing that this would make the area of darkness appear even darker.

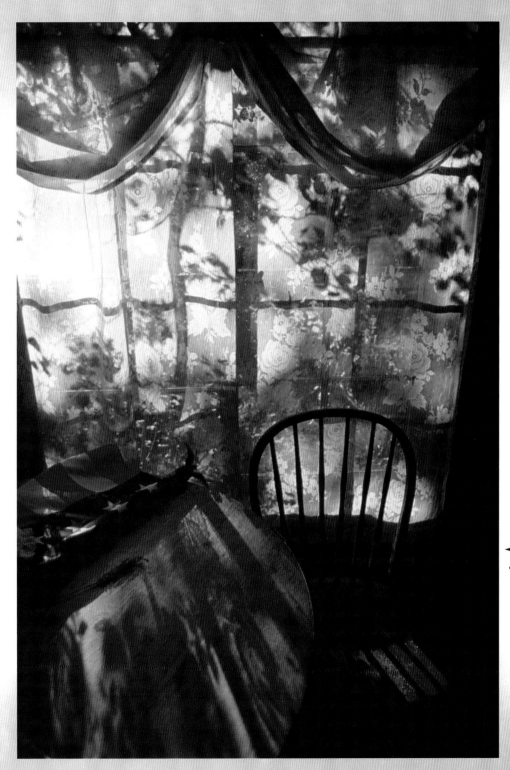

Technical Details
35mm SLR camera with a 28mm or 35mm wide-angle lens and Kodachrome 54.

Interiors (People)

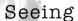

Seeing

The quality of window light in this image is soft and suits the subject in this gentle portrait. The book on the tablecloth fills up the white space without being overly distracting.

Thinking

Daylight entering a room is bound to have some of its power diminished by light-absorbing areas and objects within. The exposure chosen had to compensate for this as well as to make the most of the slow-to-medium speed film that was used.

The range of colours in this scene – yellow, red, brown and black – complement each other and the subject.

Acting

A wide-angle lens, used in the vertical format, has neatly enclosed the subject and her immediate surroundings. The photographer positioned the girl's face at the intersection of thirds to make it the focal point of this well-balanced composition.

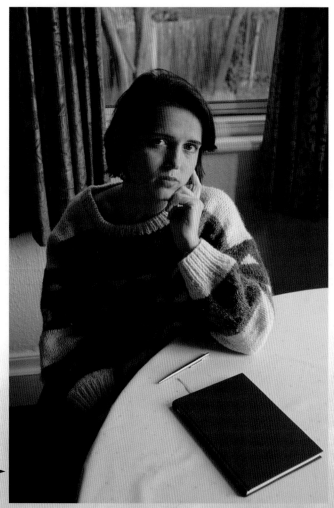

Technical Details
35mm SLR camera with a 28mm wide-angle lens and Fujichrome 100.

Technical Details
35mm SLR camera with a 28mm wide-angle lens and
Fuji Neopan b&w film.

Black and white film simplifies a subject, reducing it to blacks, whites and shades of grey. In this shot the whites of the tablecloth and the uniform are balanced by items on the table as well as the darkness behind the seated man.

The reflective surfaces have made the most of the incoming window light and provided a faster range of shutter speeds than if the tablecloth and uniform were of a darker material.

A wide-angled lens has been used to include the portrait subject plus the subject's environment.

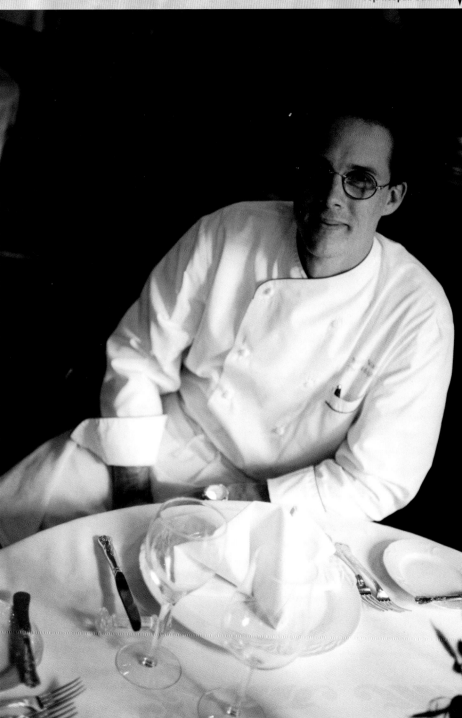

Interiors (Window Light)

Seeing

This simple quiet setting can be found almost everywhere, and it relies totally on the effect created by the soft daylight. The customers are absent yet the composition doesn't seem to require them.

Thinking

There's a limited range of colours in this scene, and most of these are subdued. The red letters spelling the word CAFE stand out and add a finishing touch to the image. The overall effect would have been different if the letters had been in black.

Acting

A still life or semi-abstract image such as this requires careful framing, with all the elements creating a harmonious balance. A simple exposure reading taken from the brightest part – the window – has automatically turned the chairs and table into a silhouette.

A standard to moderate wide-angle lens (i.e. 50 or 35mm) has been used to frame the shot. This is a lighter, smaller lens than a telephoto. Its physical dimensions allow hand-held shooting with little risk of the camera being shaken during an exposure which used a slow shutter speed.

Technical Details

35mm SLR camera with a 50mm normal lens and Kodachrome 64.

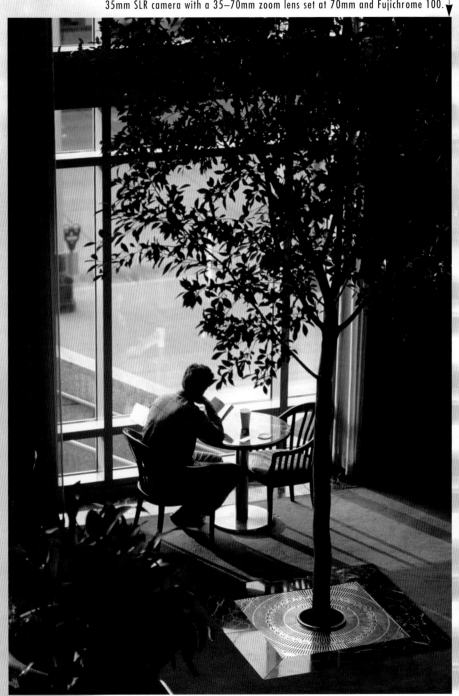

Large windows are a boon to the photographer trying to capture interiors using natural available light. Strong daylight entering a room is absorbed and lessened by interior surfaces and objects, as in this shot.

Positioning and framing were crucial to the success of an image in this situation, as was the high viewpoint.

Interiors (Natural Light)

Seeing

A photogenic interior like this one has constant appeal although some photographers will be daunted by the difficulties posed by such a subject. Here the photographer has captured the simplicity of these imposing marble pillars, and made the most of the minimal daylight that has lit them.

Thinking

Flash would have totally destroyed the subtle tones that ordinary window light has brought out in this tightly cropped scene. With its minimal colours – black, white and subtle shades of grey – this subject would succeed as a colour or a black and white image.

Acting

The photographer has tightly framed the image using a telephoto lens. This has selected this area from the whole scene and made it seem as though all three pillars are on the same plane.

Technical Details
35mm SLR camera with a 200mm telephoto lens and Agfachrome 100.

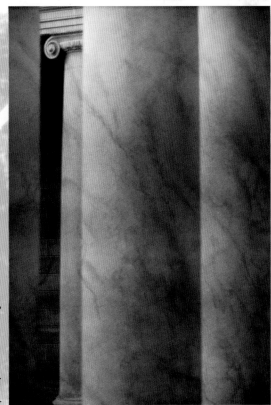

Sunlight invades these two rooms and shows the shapes and textures of the objects within them. The areas of brightness as well as the shadows are all part of the composition.

The photographer has composed the scene so as to show a good balance between the light and dark areas. It's the difference between these areas that immediately grabs the viewer's attention.

Technical Details
35mm SLR camera with a 50mm normal lens and Fujichrome 100.

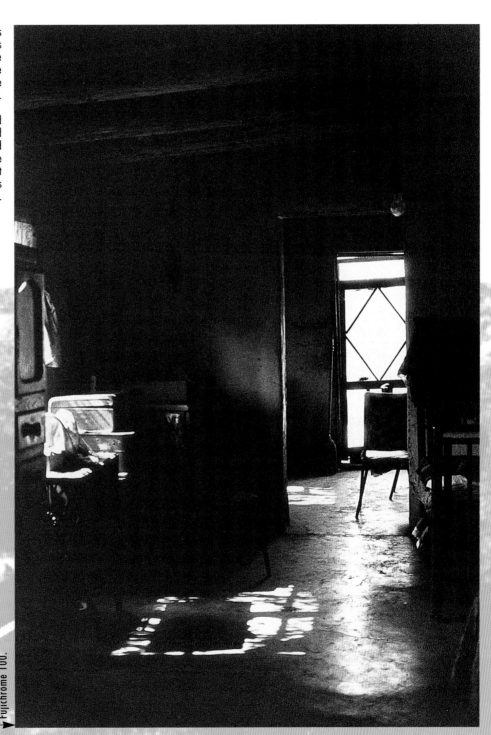

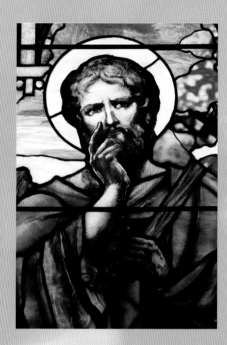

Artificial Light

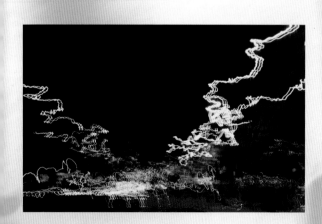

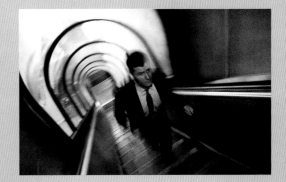

2

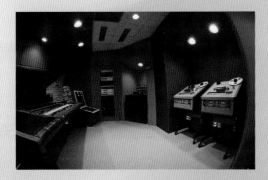

Artificial lighting is a practical necessity but
also presents problems for photographers.
Depending on the lighting in use these problems could be minimal with little or no
adverse effect on the image. Or they could be more serious, requiring corrective
measures and special accessories.
These images have been taken in a variety of artificial lighting
conditions, and show how photographers have achieved successful results
in spite of the problems.

Interiors (Lit)

Technical Details
35mm SLR camera with a 50mm normal lens
and Fujichrome 100.

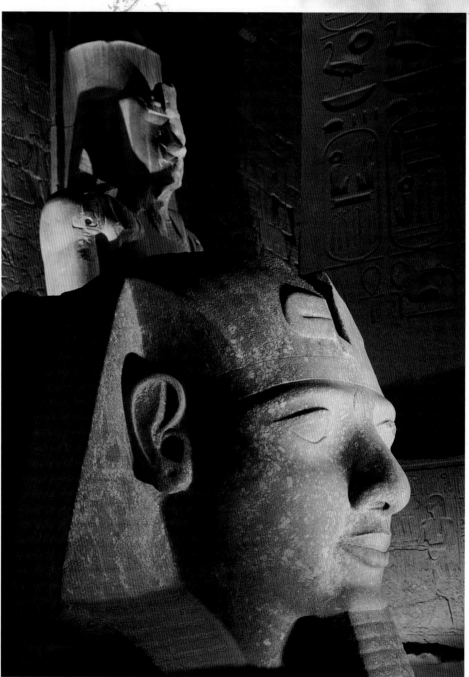

At some locations the lighting has already been set up for the photographer. The lighting in this shot of Egyptian statues emphasises their solidity and picks out the details.

The photographer was able to concentrate on the composition, and chose to fill a little more than half the image area with the imposing pharoah's head. This dominates the composition, while the second statue and background details give depth and balance.

The yellow-brown colouring is a result of daylight balanced film being used with artificial (tungsten) lighting.

Seeing

A semi-fisheye lens was used for this photograph. It has captured the vast interior of this building and helped to make a feature of the individual highlights produced by the many windows letting in daylight.

Thinking

An exposure was used that balanced the incoming daylight with the ring of artificial lighting at the centre, but without causing either of the light-sources to be over-exposed.

Acting

The lens that was used is called a semi-fisheye because the image it produces is almost like one taken with a fisheye lens, which produces a completely circular image.

Technical Details
35mm SLR camera with a 17mm semi-fisheye lens and Kodachrome 200.

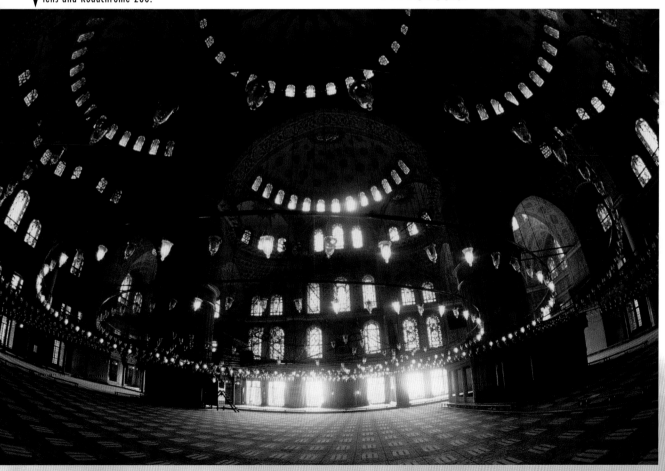

Seeing

This is an everyday scene and it took a sharp eye to see its photographic potential. Such images can have a creative as well as a historic purpose.

Thinking

The photographer realised that using a flash would be virtually impossible and if flash had been used it would have neutralised the contrast, the mix of artificial and natural lighting and the mood of this setting.

Acting

A focal length was chosen that would show the expanse of the interior and the concourse. A high position has given a commanding view and enabled the photographer to work at an undisturbed distance from the bustling crowd.

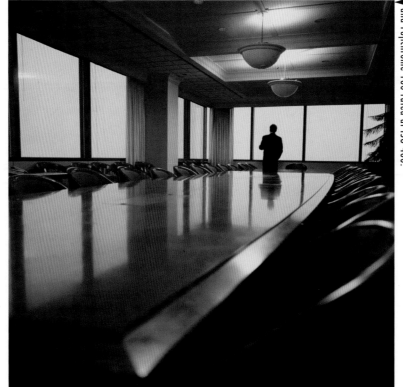

Technical Details
35mm SLR camera with a 35–70mm zoom lens and Fujichrome 100 rated at ISO 400.

The windows and large reflective conference table have combined to fill this room with illumination, making the ceiling lights seem unnecessary.

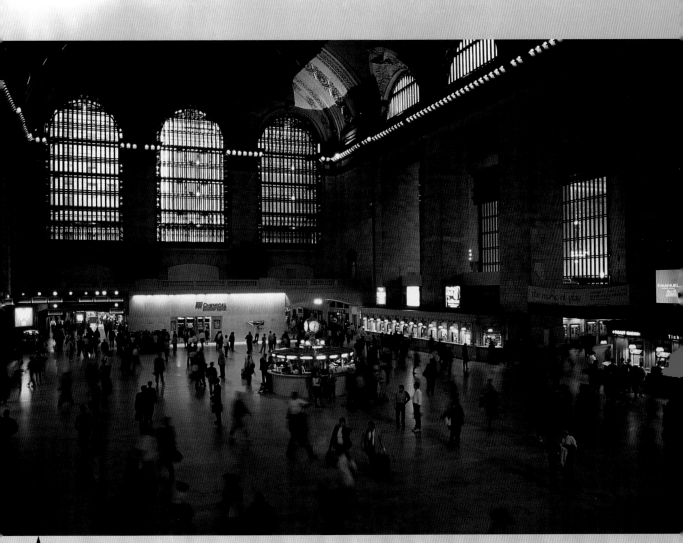

Technical Details
35mm SLR camera with a 70–210mm zoom lens and Fujichrome 400.

Seeing

Light shining through a window naturally transmits the shapes or colours of the glass itself and of anything that's attached to it. Stained glass is a great example of this, and in this image it projects its colours and framework onto the interior surfaces of a church.

Thinking

This is a simple shot which immediately informs the viewer about where the location is and what the lighting was like. It shows the stained glass window as well as the pattern it has produced.

Acting

Less exposure would have strengthened the detail and colour in the window and its projected colours, but would have darkened down the rest of the interior.

A wide-angled lens has captured a sizeable corner of the church. A common characteristic of using a wide-angle lens to shoot upwards results in converging verticals, where all vertical straight lines seem to be converging towards a point.

Where possible a special lens (called a perspective control lens) can be used which reduces this effect, though in this shot the result is acceptable and natural-looking.

Technical Details

▼ 35mm SLR camera with a 24mm wide-angle lens and Kodak Ektachrome 100.

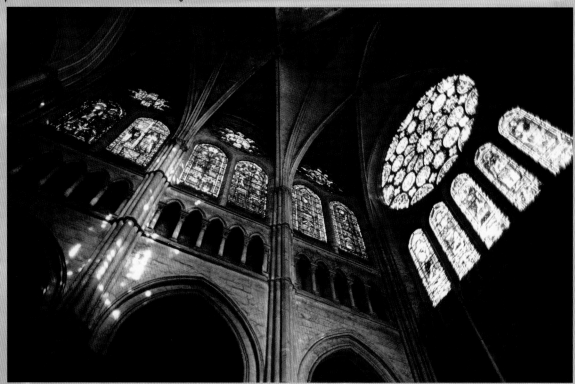

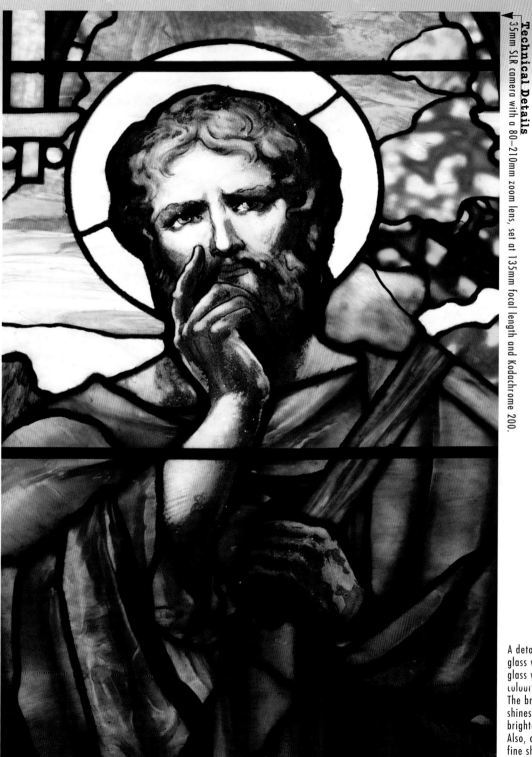

Technical Details
35mm SLR camera with a 80–210mm zoom lens, set at 135mm focal length and Kodachrome 200.

A detail from a stained glass window. A stained glass window is like a giant colour transparency slide. The brighter the light that shines through it, the brighter its colours become. Also, colour details and fine shading are seen more clearly.

Interiors (Lit)

Seeing

Many photographers would have given up in a scene such as this. The lighting is very **difficult** and there is little chance of getting a well-exposed and **sharp image**. There is not much fine detail, with the figures being reduced to **silhouettes**.

Yet the busy figures, the lowlight and the composition have all combined to create a wonderful **moody** image.

Thinking

The photographer was already aware of the **drawbacks** and decided to use them as part of the composition. The exposure setting with its slow shutter speed was crucial to convey a **strong** sense of **movement**.

Acting

The photographer took an exposure reading from the bright areas and the meter's suggested shutter speed was around 1/8 or 1/15 sec. The figures show various degrees of **blur** as they walk at different speeds.

The camera was fixed at one **location**, with the lens focused at the centre of the scene.

Technical Details
35mm SLR camera with a 70–210mm zoom lens set at 100mm focal length and Fujichrome 100.

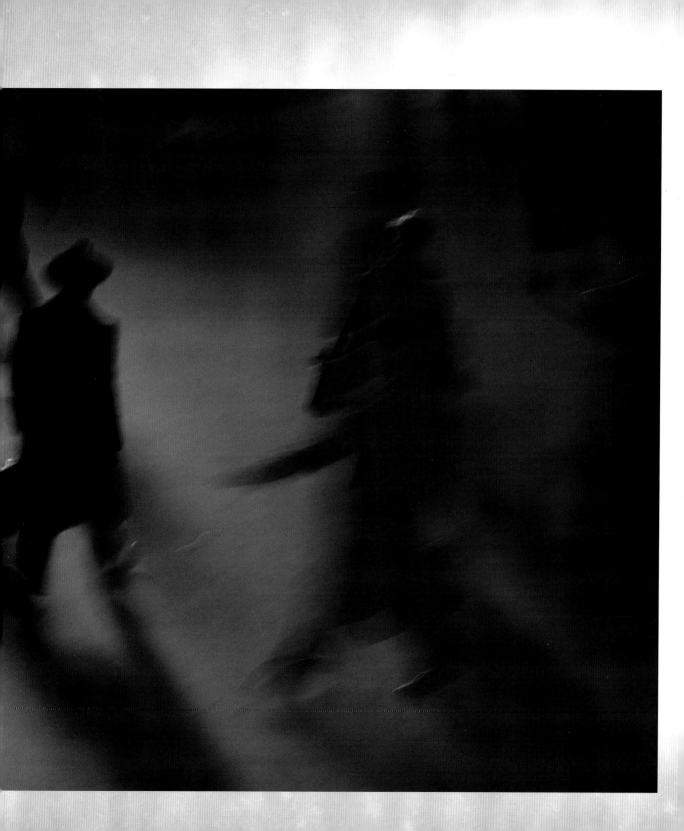

Interiors (Lit)

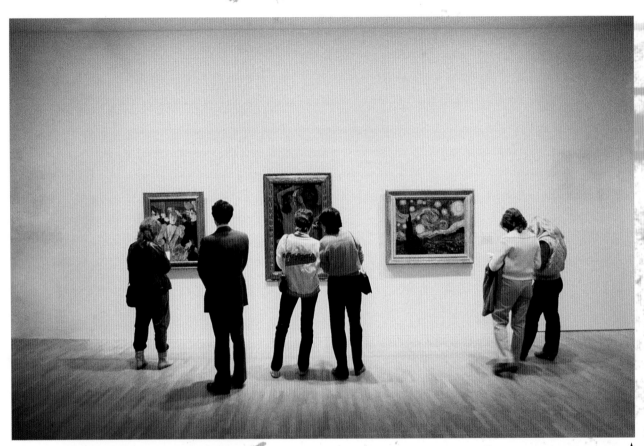

The lighting used in an art gallery to light the art works gave ample illumination for this image.
The yellow-orange glow caused by the tungsten lighting is quite acceptable. Note how the darker areas around the edge of the photograph act almost as a frame.

Technical Details
35mm SLR camera with a 50mm normal lens and Agfachrome 100.

Seeing

The photographer has successfully captured the interior view of a recording studio, lit solely by existing artificial illumination. The lighting is soft and evenly spread so that the contrast between light and dark areas is not too strong, and shadows are softened.

Thinking

The colour cast resulting from using daylight-balanced colour film in tungsten lighting can be compensated by a blue filter, which reduces the effect. However, many photographers for whom colour accuracy isn't a prime concern prefer the warm colour cast.

Acting

The photographer knew that flash would destroy the attractive effect produced by the room's artificial lighting. Instead he used a fast film to record the image. He used daylight film which, when used with tungsten lighting (found in most homes), produces a yellow-orange colour cast.

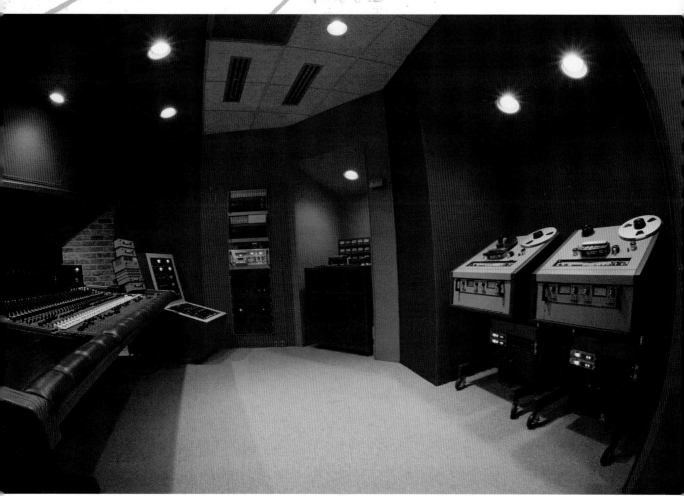

▲ Technical Details
35mm SLR camera with a 16mm semi-fisheye lens and Fujichrome 100.

Interiors (Lit)

Seeing

This is a subject that can be found in a **traditional** heavy industry **environment**, but it took a photographer to exploit the obvious photogenic possibilities.

The strong orange colour cast is right across the image and this helps to give it a strong visual impact.

Thinking

We never see the light-source but we know from the **man's attire** that what he is doing or looking at is an activity that is generating great heat. The photographer knew that, despite the **dark surroundings**, there was sufficient **reflected** light in the main subject to take a photograph.

Acting

The photographer has used a telephoto lens to fill the **frame** with the man's head. A tele-zoom lens is ideal in such a situation as it allows a range of framing options, and from a **safe distance** away. The exposure reading was taken from the man's face.

Technical Details

▼ 35mm SLR camera with a 70–210mm zoom lens set at 100mm focal length and Fujichrome 400.

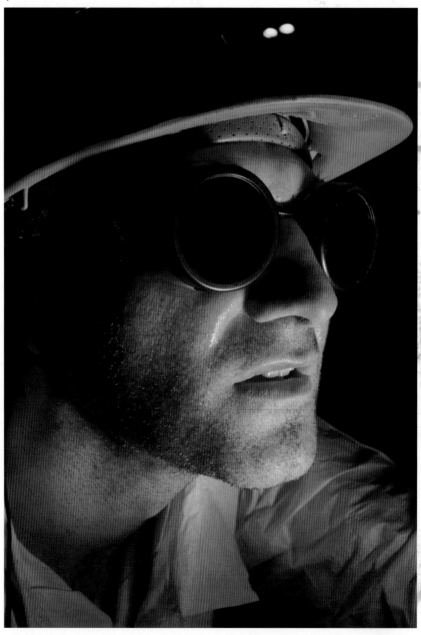

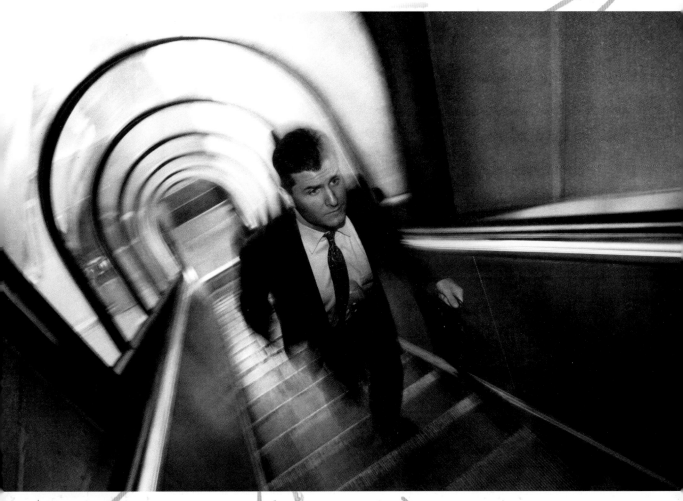

▲ Technical Details
35mm SLR camera with a 28–70mm zoom lens and Kodak Tri-X ISO 400 b&w film.

For the resourceful photographer there's usually a way around a problem. The existing light in this escalator tunnel was enough to photograph both the tunnel and the man, though not enough to illuminate his face. A small flashgun was used, pointed towards the subject's face.

The available light and the flash exposure had to be balanced. The slow shutter speed that was needed has caused the figure to blur yet the flash has sharply illuminated the man's face.

The City by Night

Seeing

Still water is a perfect natural mirror, reflecting natural and man-made objects and colours. The Capitol Building in Washington was photographed just after sunset. The ornamental pond next to it provides a mirror image of the building and the sky.

Acting

A medium format camera with a film frame size of 6x7cm was used for this shot. As a medium format camera is heavier than a 35mm one the photographer needed to steady his using a tripod.

Rule of Thumb

Medium format – a frame of medium format film is larger than a frame of 35mm film. Within medium format camera ranges there are different film frame sizes: 6x6cm, 6x7cm, 6x8cm, 6x9cm plus 6x12cm and 6x19cm. These latter sizes have wider image areas, providing panoramic frame dimensions. Each of these film frame sizes require specially designed cameras to accommodate them.

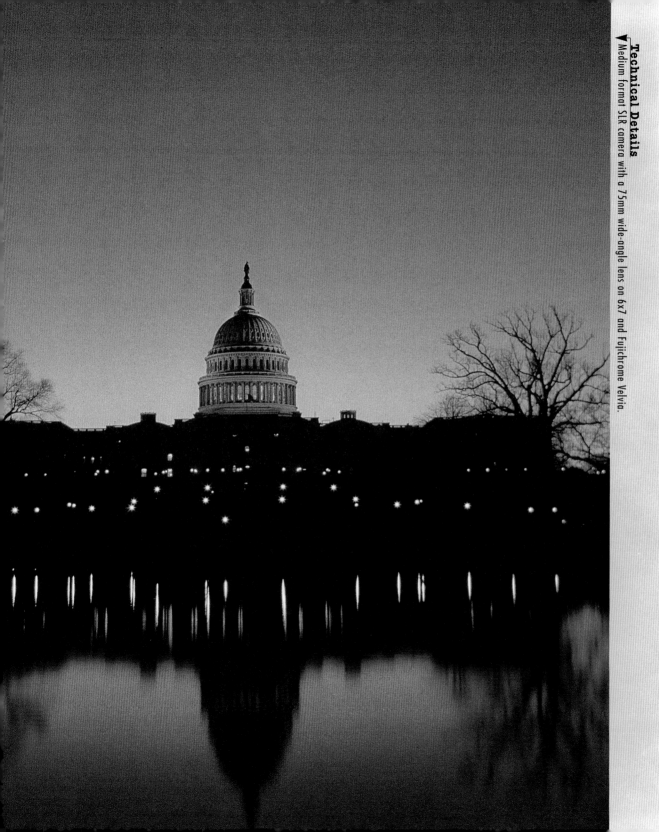

Technical Details
Medium format SLR camera with a 75mm wide-angle lens on 6x7 and Fujichrome Velvia.

The City by Night

Seeing

Night-time and artificial illumination have transformed this city skyline. The grey shades of the buildings seen in daylight have given way to a row of glowing skyscrapers against a dark sky.

Thinking

Although it's the same subject the very difference in the lighting conditions have required two very different picture-taking procedures. For instance, the daylight shot could have been taken without a tripod and at a fast shutter speed. The night-time shot required a tripod as a support for the camera and a shutter speed measured in seconds.

Technical Details
35mm SLR camera with a 300mm telephoto lens and Kodachrome 200.

Acting

Though a tripod was used for the second shot, the composition and framing were similar to that used in the daytime image. With the night-time shot the photographer took an exposure reading from the brightest area then took several shots at and around this setting, using a procedure known as bracketing.

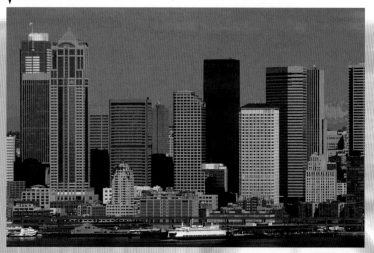

Technical Details
35mm SLR camera with a 80–200mm zoom lens and Fujichrome 400.

Rule of Thumb

Bracketing increases the chance of getting an image that has the right exposure when photographing in difficult lighting conditions. Bracketing is often required in these situations because the camera's suggested 'correct' exposure setting – which would be adequate for normal daylight conditions – would have produced an incorrectly exposed image in such non-standard lighting.

This is the way that bracketing works: One shot is taken at the camera's suggested 'correct' setting, and then one each is taken at exposure settings lower and higher than the correct setting.

Technical Details

35mm SLR Camera with a 200mm telephoto lens and Fujichrome 100 film pushed to ISO 200.

A telephoto lens has captured these three skyscrapers, making an interesting semi-abstract pattern of their windows. The exposure has reduced them to a series of black and white squares and rectangles.

This shot was taken from a neighbouring building. A secure viewing gallery or a simple office window provides ways to photograph skyscrapers from adjacent buildings at the same height.

The City by Night

Seeing

This older skyscraper gives off an eerie glow and stands out in this image of a city skyline by night. It is the brightest part of the scene and its position in the centre of the frame makes it the natural focal point.

Acting

The photographer used black and white infra-red film, a special film which is extra sensitive to subjects which give off heat, and can record their heat as an image. The extensive lighting in the central building plus slight over-exposure have produced the intense glow.

Thinking

The image was carefully planned long before it was taken. The photographer was already familiar with the special characteristics of b&w infra-red film and was aware of the way it would react with the artificial lighting.

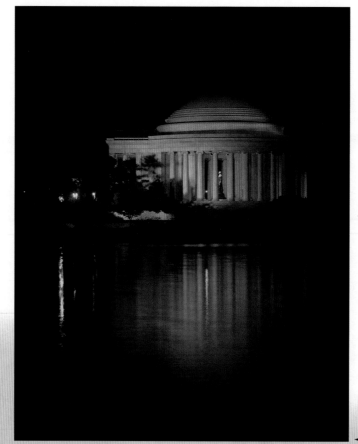

The Capitol Building, taken at night and against a background of darkness. The effect is peaceful and easy on the eye. The only lighting is provided by the building's artificial and nearby illumination.

Notice how the water has stretched the reflection.

35mm SLR camera with a 70–210mm zoom lens and Kodachrome 200 film at ISO 400

Technical Details

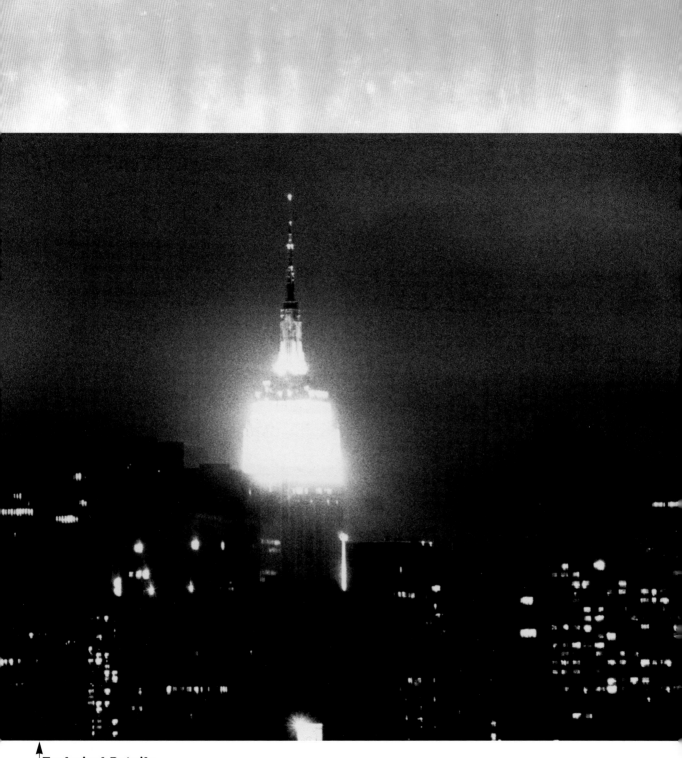

Technical Details
35mm SLR camera with a 80–200mm zoom lens and Kodak Tri-X ISO 400 b&w film.

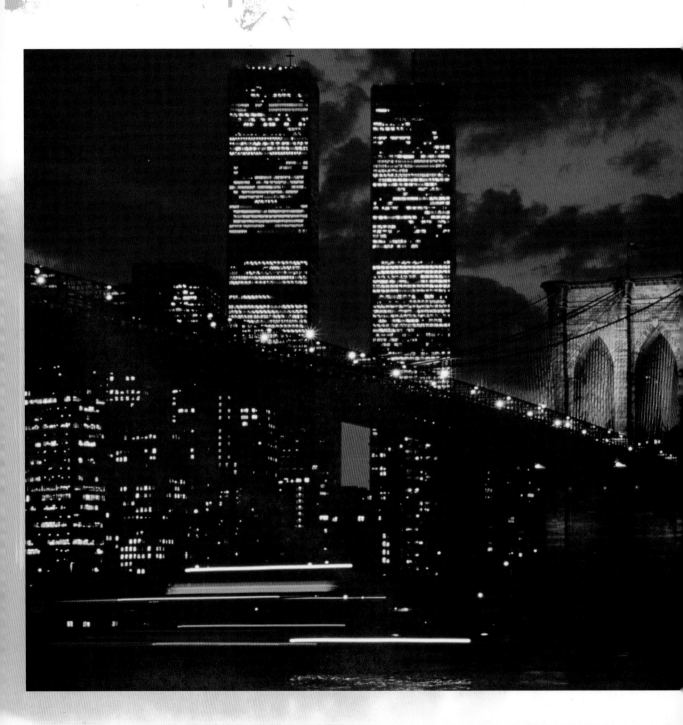

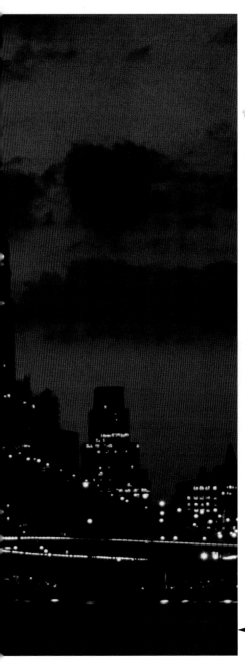

Seeing

A classic night-time view of a New York skyline. The frame has been completely filled and the diagonal line formed by the bridge divides the picture into two parts, creating a perfectly balanced composition.

Thinking

The photographer has strived to make something more than just the usual skyline shot. The streaked light trails at the bottom left of the picture have been used to fill in that area, adding interest and a sense of movement.

Acting

An exposure setting with a shutter speed of a few seconds has effectively captured the illuminated buildings and sky, without over-exposing either.

The slow exposure has also caused the lights of the moving boats to record as light trails.

▶ Technical Details

35mm SLR camera with a 300mm telephoto lens and Kodachrome 200.

The City by Night

Seeing

A classic image of neon lighting against an evening sky. It has been filled with interest and colourful detail, with no part of the image area being wasted.

Thinking

Neon lighting presents a few problems for photographers. Daylight- balanced film can be used, with no significant or distracting colour casts. And setting the exposure for a neon light or several of them involves simply taking a reading then increasing the exposure by half to one stop.

Acting

A 24mm or 28mm wide-angle lens was used to include the walking figure, the neon porch and the street skyline. In good lighting conditions a tripod may not always be necessary, even if a medium-speed (i.e. ISO 100) film is used.

Technical Details
▼ 35mm SLR camera with a 28mm wide-angle lens and Fujichrome 100.

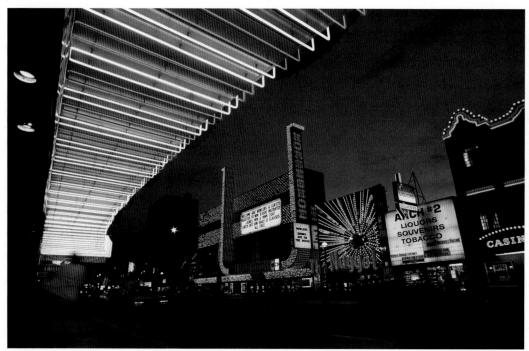

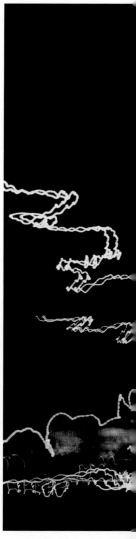

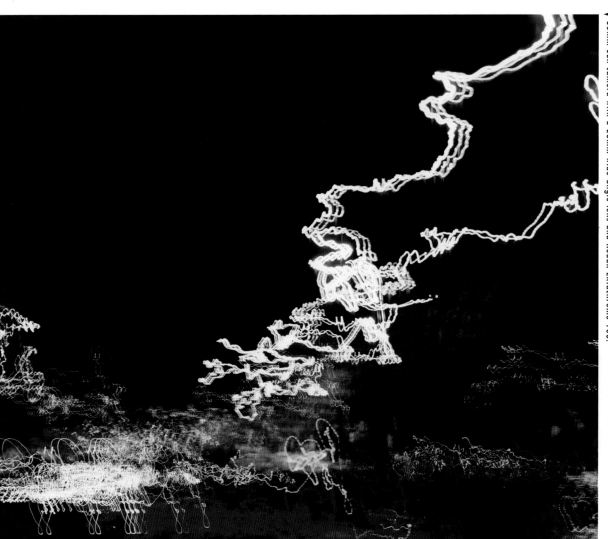

Technical Details
35mm SLR camera with a 28mm wide-angle lens and Kodak Ektachrome 100.

No special effects filters or trickery were used for this striking abstract image. The photographer simply photographed a plane and runway lights, using a handheld camera and a slow shutter speed. The camera shake caused by the slow shutter speed plus the plane's moving lights combined to cause the irregular light streaks.

The City by Night

Technical Details
35mm SLR camera with a 28mm lens and Kodachrome 64. ▼

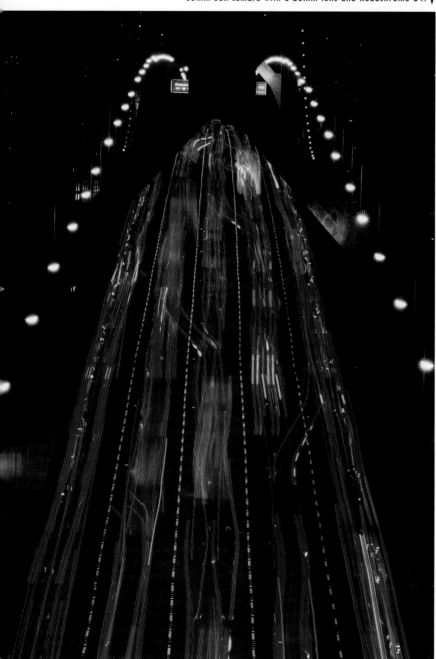

Seeing

The light trails caused by the cars' headlights convey the energy and movement of a freeway. The image shape and careful composition lead the eye easily into the image.

Thinking

With a longer shutter speed the light trails would have become elongated. The individual cars would have become more blurred and been less easy to distinguish.

Acting

The shutter speed was around 1/2 sec to 1 sec. At these speeds and with a tripod-mounted camera a cable release is not always necessary. A bridge across the freeway acted as a superb and safe viewing platform for the photographer.

A head-on photograph of a bridge at night taken from a high viewpoint. A shutter speed of several seconds has ensured that the tail-light trails of the traffic have blurred into long red streaks.

Seeing

An experienced photographer planned and designed this image long before he set up his camera at this location. The white and red streaks of traffic coming towards and going away from the camera have been beautifully balanced with the twilight city skyline.

Thinking

Knowing beforehand what shutter speed would produce the best streak effect of moving traffic the photographer composed the image so that the streaks and the skyline would share an almost equal area. In order to do this the invisible line that signifies the horizon was positioned at the centre half of the frame.

Acting

The shutter speed that was needed to capture the car light trails was the photographer's priority when working out the exposure setting. He already knew that an exposure of a few seconds would be an acceptable setting for the city skyline.

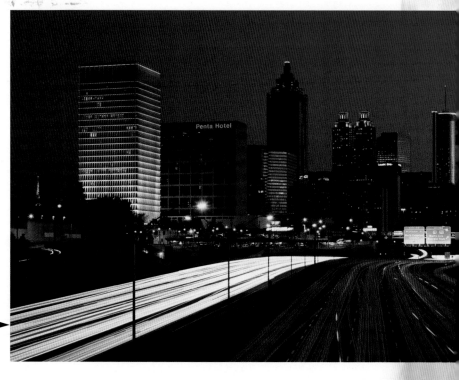

Technical Details ➤

35mm SLR camera with a 80–210mm zoom lens set at 100mm focal length and Kodachrome 200.

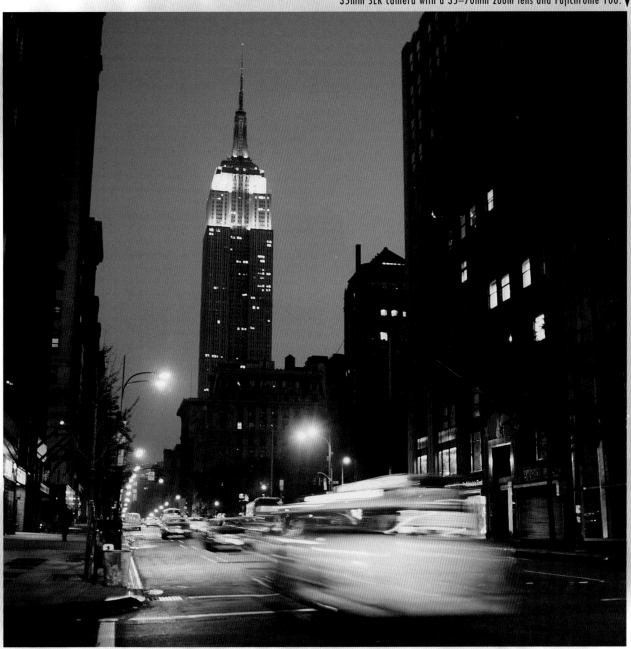

The use of a slow shutter speed with a light, moving object has created a
strange and beautiful smeared shape that could never exist in real life.

Fireworks

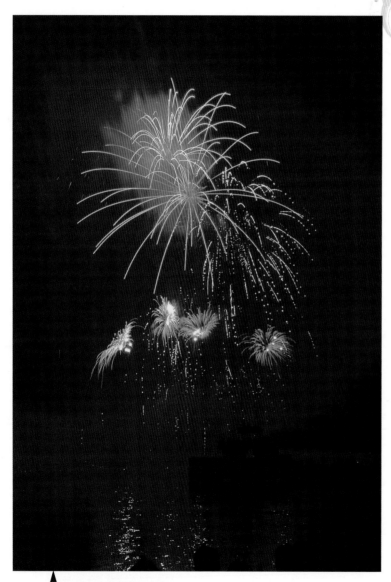

Seeing

A fireworks display, water reflections of it, and some of the audience that have come to watch it are all included in this striking image.

Thinking

It's difficult to predict exactly where a burst of fireworks is going to appear in the frame, but a prearranged display, a good viewing position and a wide-angle lens all help to improve the photographer's chances of getting a great shot.

Photographing fireworks is one of the most demanding skills of action photography. However, a lot of the skill is in the positioning of the camera and the photographer's framing, rather than the exposure. Most of the time using the B setting and an aperture of f/8 or smaller will suffice.

Acting

Photographing fireworks is easy. First the shutter speed is set to B and an aperture setting of f/5.6 or f/8 is chosen. The shutter should be kept open long enough for a fireworks display sequence to take place, then it should be closed.

Technical Details
35mm SLR camera with a 28–85mm zoom lens set at 60mm focal length and Kodachrome 64.

Camera shake has helped to create an unusual fireworks image. The slow shutter speed – around 1 to 2 seconds – has resulted in blurred city lights plus blurred fireworks seen in the background between the two buildings.

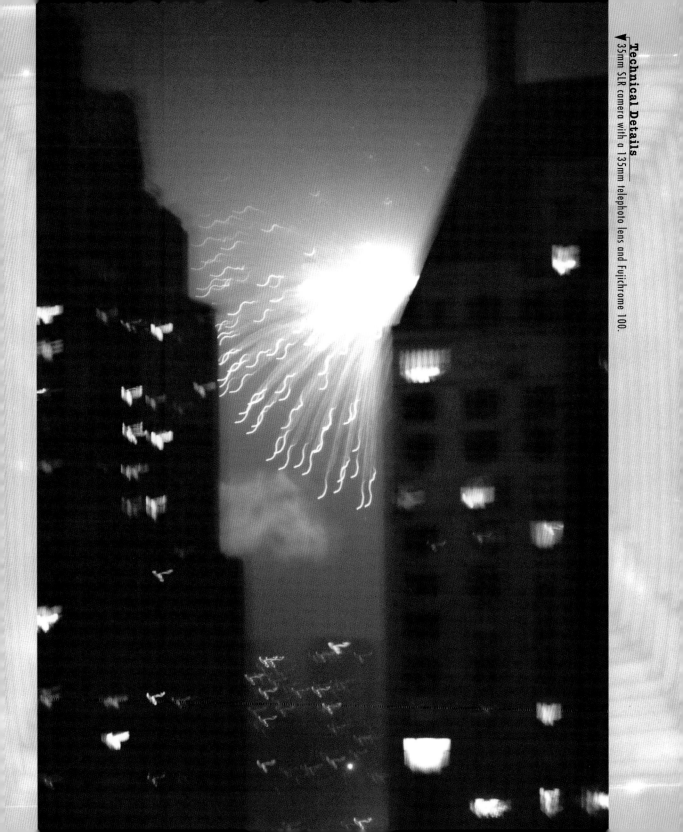

Technical Details
35mm SLR camera with a 135mm telephoto lens and Fujichrome 100.

Fireworks

Seeing

A briefer than usual shutter speed of around 1/4 or 1/2sec has shortened the fireworks light trails, giving the image the appearance of a delicate plant.

Thinking

Breaking the rules sometimes leads to interesting shots, as it shows here. Photographers should always experiment in the hope of discovering a brand-new photographic special effect.

The brief exposure has also made the surrounding area appear darker.

Acting

A shutter speed of between 1sec to 1/15sec lasted only long enough to record the first segment of this fireworks sequence. Even with briefer speeds such as these a tripod is essential to make sure that the light trails of the fireworks do not show the effects of camera shake.

Technical Details
35mm SLR camera with a 35–70mm zoom lens and Fujichrome 100.

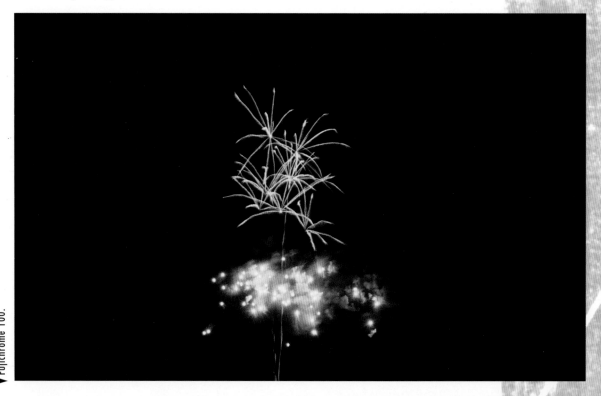

Technical Details
35mm SLR camera with a wide-angle lens and Kodak Ektachrome 100.

A wide-angle lens covered a large expanse of sky, including the lit building and the fireworks display above it. Position is the key to a successful fireworks photograph. Arrive early and find a good tripod and viewing position.

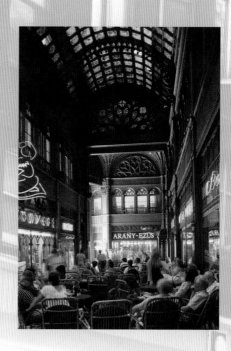

Mixed Lighting
Flash & Daylight

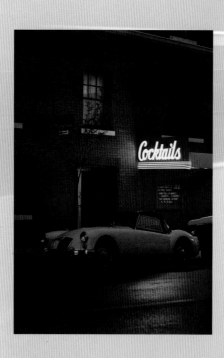

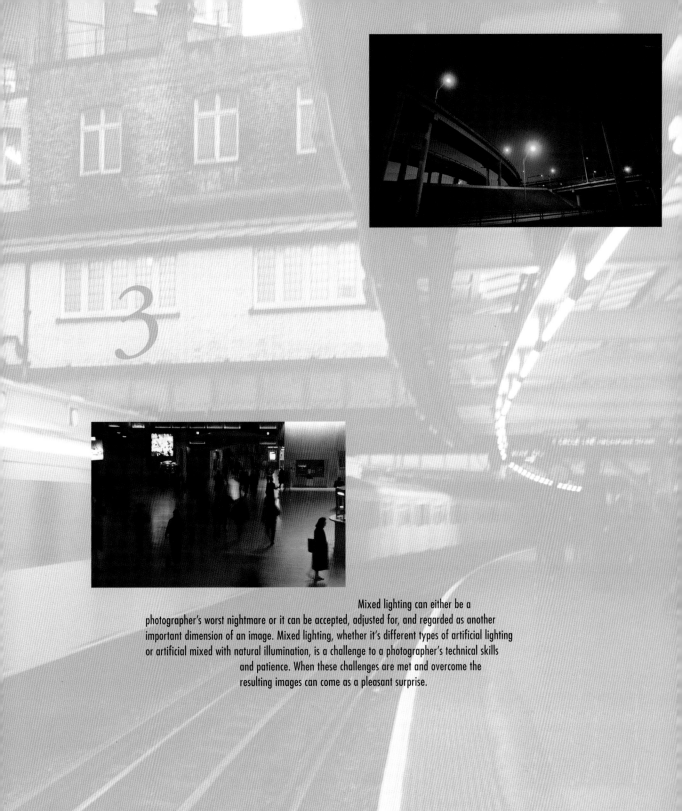

Mixed lighting can either be a photographer's worst nightmare or it can be accepted, adjusted for, and regarded as another important dimension of an image. Mixed lighting, whether it's different types of artificial lighting or artificial mixed with natural illumination, is a challenge to a photographer's technical skills and patience. When these challenges are met and overcome the resulting images can come as a pleasant surprise.

Flash Indoors & Outdoors

Seeing

Mixing flash with daylight is a way to illuminate an outdoors subject when existing light levels are low. It's popular with portrait and fashion photographers and, as in this image, the effect it creates is unusual and eye-catching.

Thinking

As results are unpredictable, several shots need to be taken. The flash can be used on the camera or, connected to the camera by a flash lead, it can be used independently of the camera to give some varied lighting angles.

Acting

An exposure reading was first taken for the existing lighting to ensure that the subject would be properly exposed. A slow shutter speed was chosen so that the film continued recording the image long after the flash was fired.

The technique is called synchro-flash and is offered as an optional automatic feature on some compact cameras and SLR cameras.

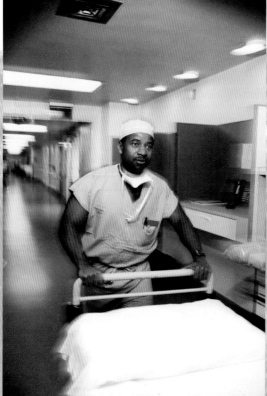

Technical Details — 35mm SLR camera with a 35–70mm zoom lens set at 35mm focal length and Fujichrome 100 at ISO 200.

Here flash has been perfectly balanced with the hospital lighting so that the man and his surroundings are correctly exposed. However, the slow shutter speed that was necessary as part of the exposure has caused some blur, because the subject was photographed in motion.

35mm SLR with 50mm lens, and a separate portable flashgun. ISO 100 colour transparency film.

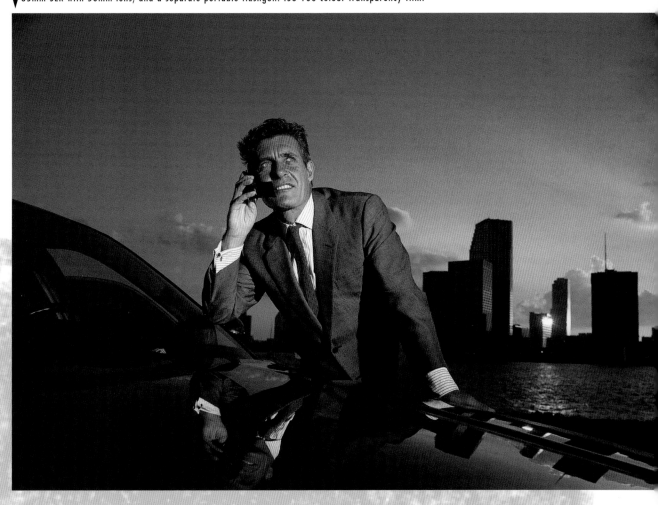

Flash Indoors & Outdoors

▼ 35mm SLR camera with a 50mm normal lens and Fujichrome 100.

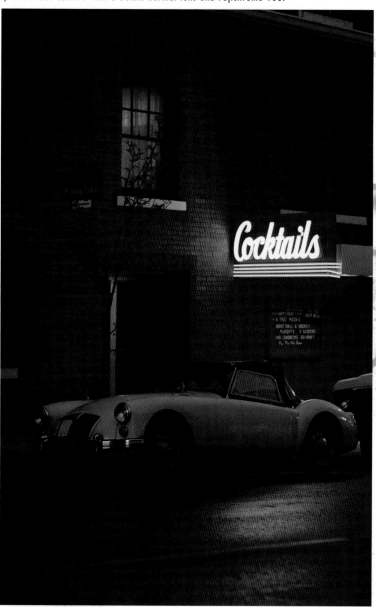

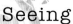

Seeing

Neon signs give out vivid and interesting coloured illumination that lights up a night scene and nearby objects. Here the sign has lit up part of the front of this building as well as the car and roadway.

Thinking

As well as being a photogenic image the combination of the sign and the car evoke a certain lifestyle. Many city streets have similar subjects, which can be safely captured from a position on the opposite pavement.

Acting

The photographer crouched down low so as to include a large expanse of the roadway in the frame, as well as to make it appear that the sign and car were closer together.

He took a reading from the neon sign and then bracketed his shots. After some experience the practiced photographer will be able to guess the nearest exposure settings, so that fewer frames will be required when bracketing.

A deserted or semi-deserted freeway at night with a clear sky behind and random street lights gives a moody, eerie atmosphere. A wide-angle lens has included the expanse of road architecture, giving a sense of spaciousness.

Technical Details
35mm SLR camera with a 28mm wide-angle lens and Kodachrome 64.

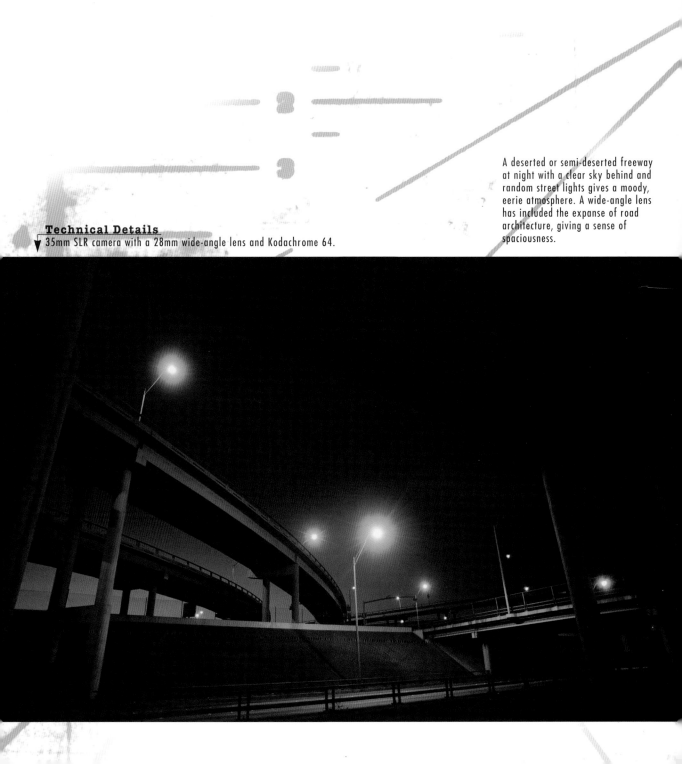

Seeing

A major and unavoidable problem was the effect of flare which gave a softening effect and lowered contrast. The flare was caused by points of bright illumination from spotlights entering the lens and spreading across its surface.

Thinking

This subject may not automatically be the first choice of a photographer yet it has photogenic possibilities. It is also a good exercise in interior photography.

Because much of this type of lighting is close to the colour balance of daylight film, colour compensating filters or specialised film may not always be needed.

Acting

The photographer chose a viewing position that excluded the spotlight from the image frame. The through-the-lens viewing system of an SLR camera proved helpful here. An additional precaution was a lens hood, which further reduced the effect of flare.

Technical Details

35mm SLR camera with a 50mm lens and a separate portable flashgun. ISO 100 colour transparency film ▼

Technical Details
35mm SLR camera with a 24mm lens and Agfachrome 100.

Ordinary daylight plus different types of artificial lighting feature in this cafe-bar interior. The result is a harmonious mixture of illumination that creates a vibrant atmosphere.

A wide-angle lens was used to frame the image. The vertical format gives an impression of height and spaciousness.

Seeing

In this busy concourse mixed lighting is the light source as well as the subject. The three main sources of illumination react differently to daylight-balanced colour film and produce different colour casts.

Acting

A high position gave an expansive view and showed more of the scene than if the shot had been taken at ground level. Also from this angle the camera was less intrusive.

Technical Details
▼ Compact camera with built-in 35–70mm zoom lens and Fujichrome 100.

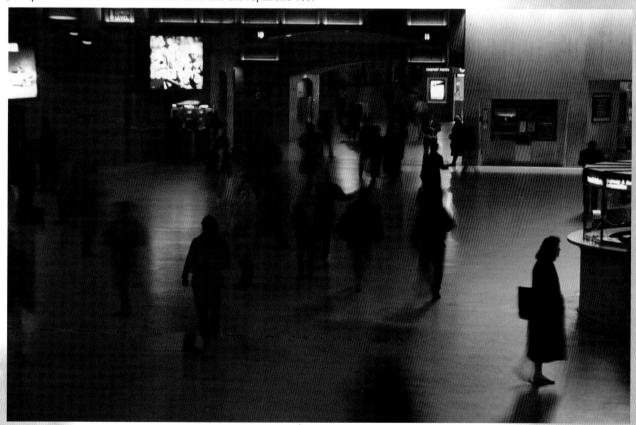

Night Lights

Seeing

The photographer was commissioned by a tourist authority to take this image of the Menai Straits Bridge in Wales. The long exposure used has caused the moving clouds to register as a blur.

Thinking

A spot-meter was used to take an exposure reading off an area of midtone. Another reading was taken from the light on the towers. The resulting calculation produced an exposure time of around one and a half minutes.

Acting

He chose to use a 6x7cm medium format film and the camera was mounted on a tripod. During the exposure the lens was uncovered only to record car light trails.

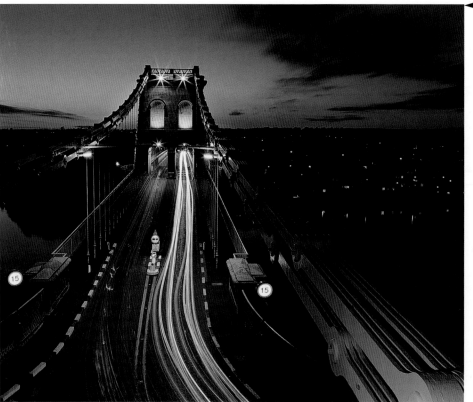

Technical Details
6x7cm medium format SLR camera with a 75mm wide-angle lens and Kodak Ektachrome 64.

This was taken from a hotel room window using a tripod. The photographer chose an exposure that gave a bright view of the scene and that illuminated some building details. If the photographer had reduced the exposure the overall scene would have been darker but the artificial lighting would have appeared more vivid.

Technical Details

Compact camera with built-in 35mm wide-angle lens and Fujichrome Velvia. ▼

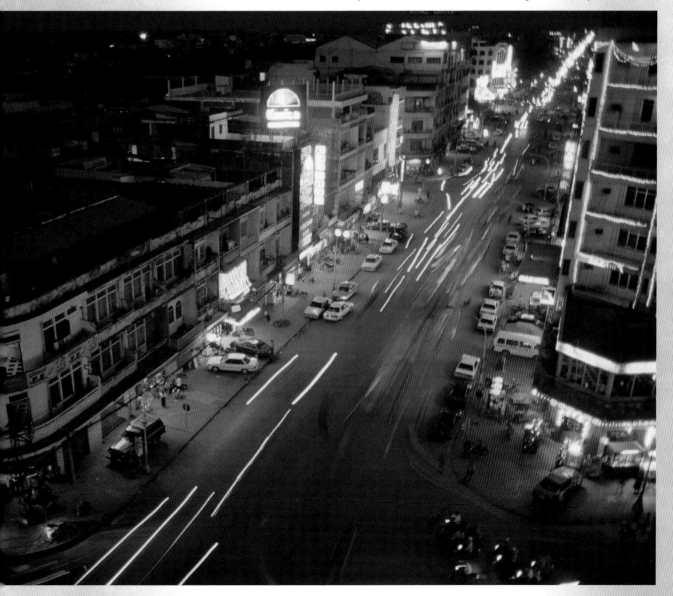

Movement

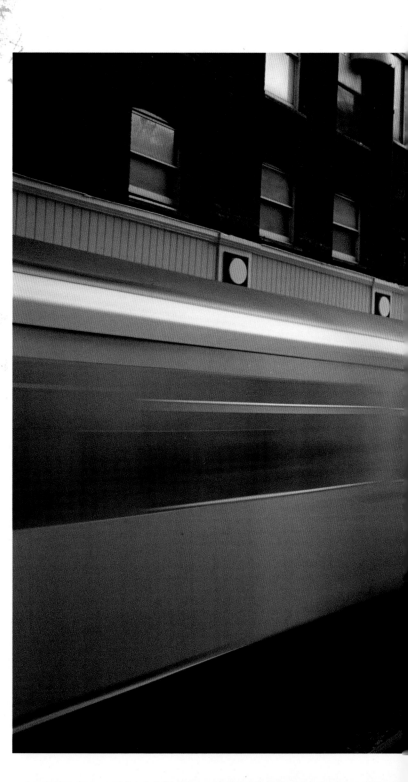

Seeing

The train coming in from the left creates a dynamic shape which points towards the centre of the image. It is balanced by the platform details on the right.

Thinking

The photographer positioned himself at a chosen spot before the train arrived. When composing the shot he allowed space at the left of the composition for the train to fill.

Acting

A wide-angled lens has allowed the photographer to include a section of rail track while shooting from the safety of the platform.

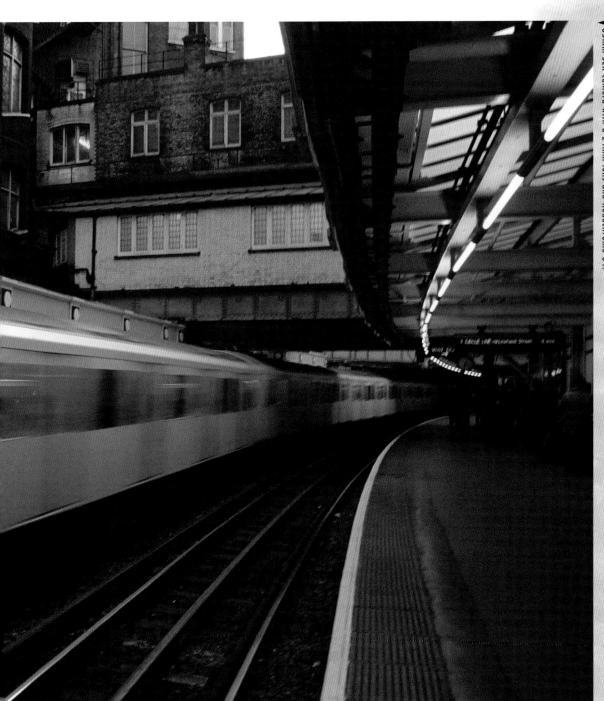

Technical Details

35mm SLR camera with a 24mm lens and Kodachrome 64.

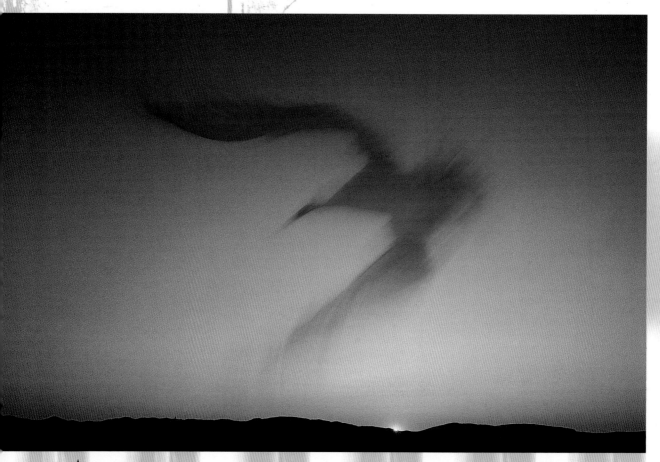

Technical Details
35mm SLR camera with a 35–70mm zoom lens and
Fujichrome 100.

The slow shutter speed used for the sunset
image has made a blurred shape of the
flying bird. A faster shutter speed would
have made the bird appear sharper, but the
exposure setting would have caused the sky
to become darker.

Seeing

This image is full of movement and, with the bright lights, is an excellent example of a busy city street by night.

Some of the vehicles at the centre have just turned, shown by the shape of the light trails they've left behind.

Thinking

Photographers who are inspired by such subject-matter constantly strive for one image that sums up the vibrant, brash atmosphere of a busy night-time street. The photographer who took this picture has successfully achieved this.

Acting

A safe position and a moderate telephoto lens has made the traffic and buildings seem closer together than they really are. A small aperture has been used to ensure that the scene from the front to the back of the image falls within the area of sharpness (i.e. depth of field).

Using a small aperture can sometimes create a star shape from a bright light source, which is seen in the car's headlight to the right of the picture.

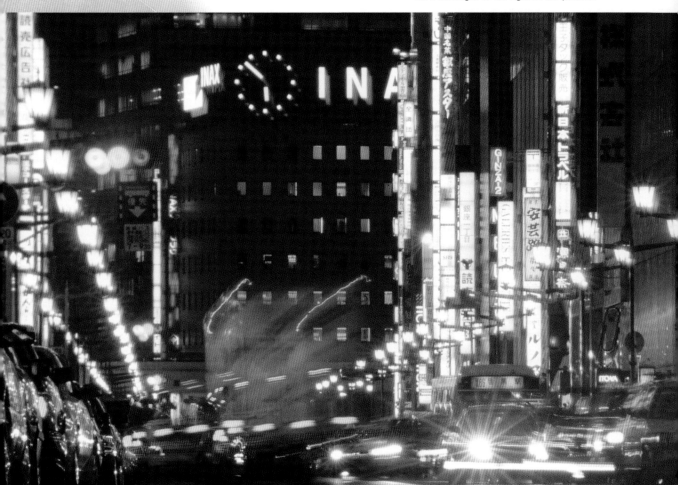

▲ Technical Details
35mm SLR camera with a 100mm telephoto lens and Agfachrome 200.

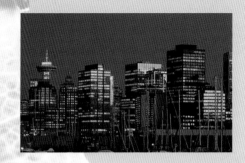

Cameras & Equipment

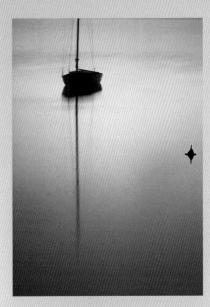

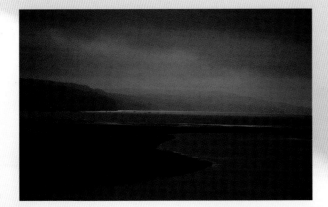

There's a range of image formats available to the
lowlight photographer and which one is chosen
depends on how and where the images will be used.

Choosing a Camera

Medium format

Medium format film is excellent for photographing subjects where very fine detail needs to be recorded. The intensity of illumination in this image demands the viewer's attention. Medium format film is much larger than 35mm film, but provides fewer frames per roll of film.

35mm format

The 35mm format is versatile. It enables the use of smaller cameras which are more portable than medium format models and are easier to set up for location photography, whether for action subjects or static subjects like this.

Technical Details

▼ 6x7cm medium format camera with a 55mm wide-angle lens and Fujichrome 100.

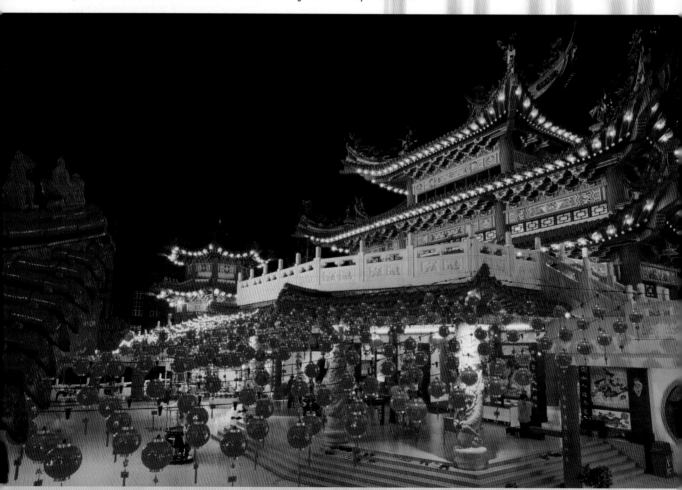

Technical Details

35mm SLR camera with a 135mm telephoto lens and Kodachrome 200.

View camera

View cameras are used for the highest quality results with fine image detail. They are perfect for photographs such as this, where precise positioning and the finest detail are needed.

Film formats for use with view cameras are mainly 5x4in and 10x8in. The cameras used are large and not as portable as the 35mm and medium format types. They demand more technical photographic skill but produce larger images.

N.B. The long exposure has caused a colour cast, as a result of Reciprocity Law Failure (see page 24).

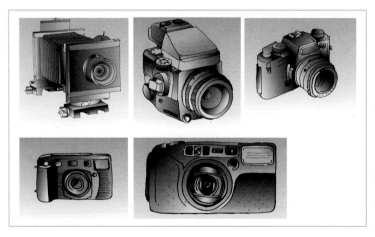

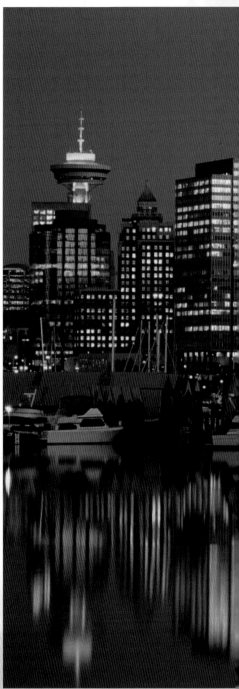

(Clockwise from left) View camera, Medium format camera, 35mm SLR and 35mm Compact cameras.

View cameras use a large film size, usually 5x4in or 10x8in. Their bellows are useful for adjusting the image in still-life and architectural photography.

Medium format cameras use a film format larger than 35mm; typical film sizes are 6x6cm, 6x7cm, and 6x9cm.

35mm SLR cameras are widely used by professional and amateur photographers. They are light, portable and have a greater choice of lenses and accessories.

35mm compact cameras are smaller than SLRs, and are popular for snapshots and general photography.

APS cameras use a smaller film format than 35mm. This results in a smaller more portable camera that's ideal for snapshots.

Technical Details

▼ 5x4in view camera with a 300mm telephoto lens and Fujichrome Velvia.

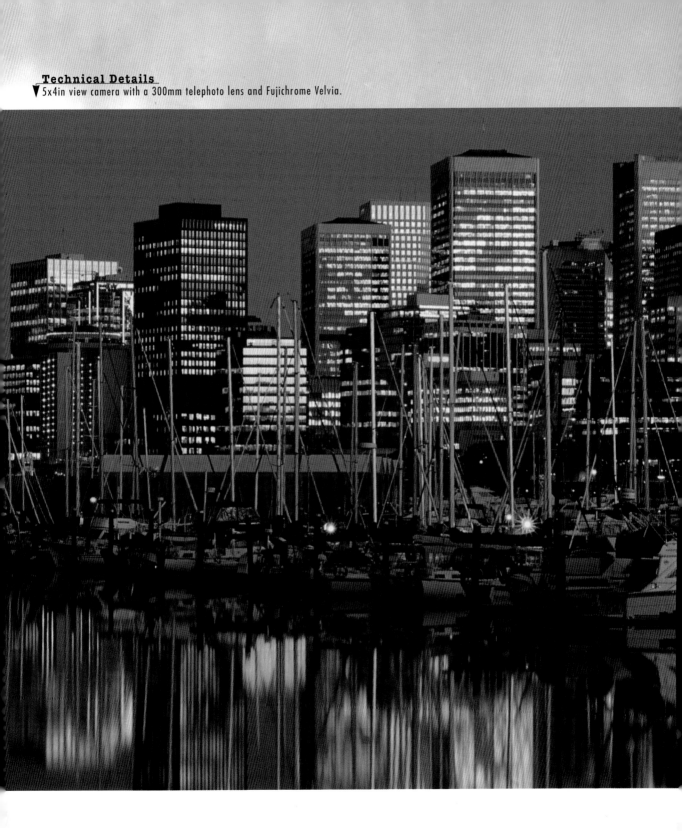

Choosing lenses

The choice of lens depends on the subject you wish to photograph. Generally, a wide-angle lens is used for recording a large part of a scene, such as a landscape or an interior. It is also used to photograph group portraits.

A telephoto lens is used for individual portraits and for making distant subjects appear to be closer to the camera. They are popular choices for sports and nature photography.

A zoom may contain a range of wide-angle and telephoto lens focal lengths in just one lens.

Technical Details
▼ 35mm SLR camera with a 50mm lens, and ISO 400 colour transparency film.

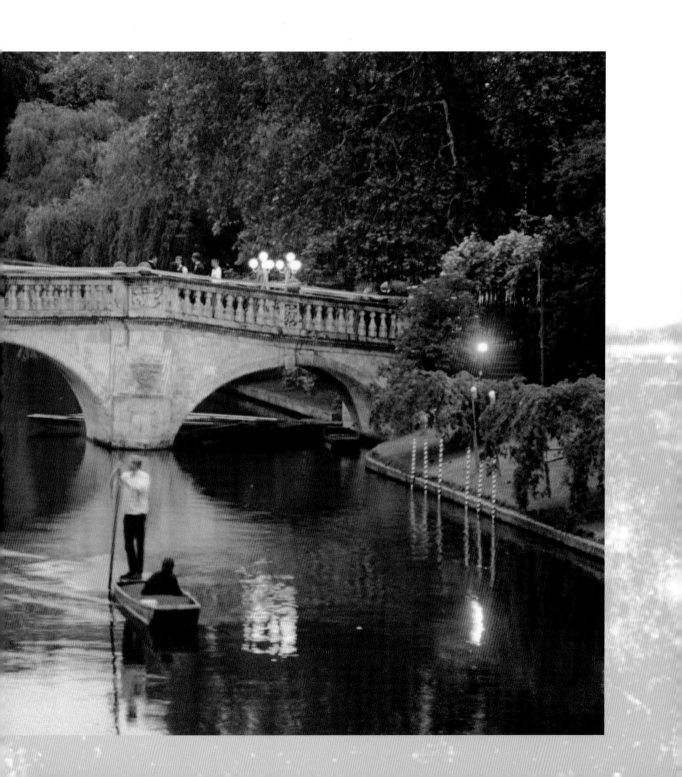

Camera Accessories

A close-up or **macro lens,** or a close-up bellows attachment opens up a new world of photographic subject-matter. Fine details and textures that are not immediately available to the **naked eye** can be made to fill the frame.

Many zoom lenses have a **close-up** option which offers close focusing capabilities.

Also available are special close-up attachments that work like **filters**. They come in different close-up magnifications and, like filters, they can be screwed onto the front of an **ordinary lens.**

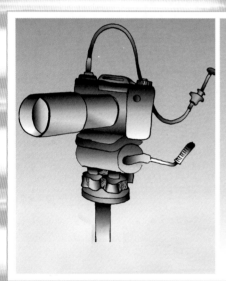 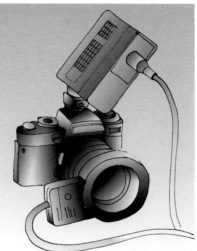

A cable release enables the shutter button to be pressed without the photographer touching the camera. It's useful for using slow shutter speeds without jogging the camera.

A Ringflash is a circular flashgun that fits around the front of the lens. This attachment creates even shadow-free lighting that's ideal when photographing close-up subjects.

A tripod with a tilting head allows the camera to be pointed down towards a close-up subject. An adjustable central column enables the camera to be moved closer to or further away from the subject.

Technical Details
▼ 35mm SLR camera (tripod-mounted) with a 100mm macro lens and Fujichrome 100.

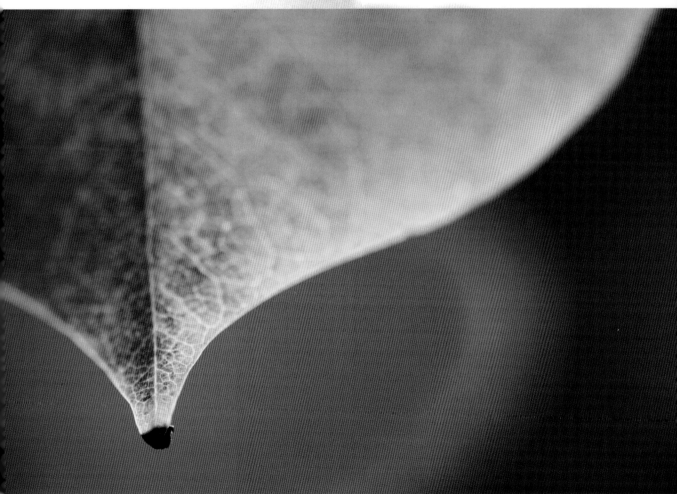

Lighting Equipment

Studio flash gives complete control of subject lighting. As in this image, a skilled photographer can produce almost **shadow-free** images using powerful and carefully positioned studio flash. A flash meter acts like a normal meter for measuring daylight, except that it measures the output of a particular **studio flash**. The way it works is that the meter is first connected to the camera and the studio flash. When the flash fires the F/ Meter shows the aperture that should be used for a correct exposure.

This suggested correct exposure setting, as with a **daylight** reading, should be considered a guide only.

There are other aspects needed to be considered before the shot is taken, such as which other studio flash units are being used and their power outputs and whether diffusing material or coloured filters (gels) are being used over the studio flash heads. Some of the attachments used with studio flash to control lighting are:

Bowl Reflector: This is a shallow silver or white bowl that fits around the flash head. It's used for spreading the flash illumination.

Barn Doors: These are used not just for spreading the illumination but also to direct it to a specific area, by adjusting flaps or barn doors.

Snoots: A snoot is a narrow cone that fits over the flash head, creating a narrow beam of light. It is used to light a small part of a subject.

Umbrella Reflector: This is a device that looks like a real umbrella and attaches to the flash head. It can be used as a reflector, bouncing **flash** illumination onto the subject.

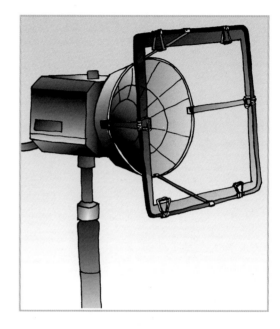

Above; a typical studio flash head. This one has an attachment that can take diffusing material or special coloured filters (gels).
Right; A separate portable flash gun can be used for fill-in flash. Depending on its power output it can be used for close or distant work.

Technical Details
▼ 35mm SLR with a 35–70mm zoom lens, and ISO 400 colour transparency film

Apertures & Shutter Speeds

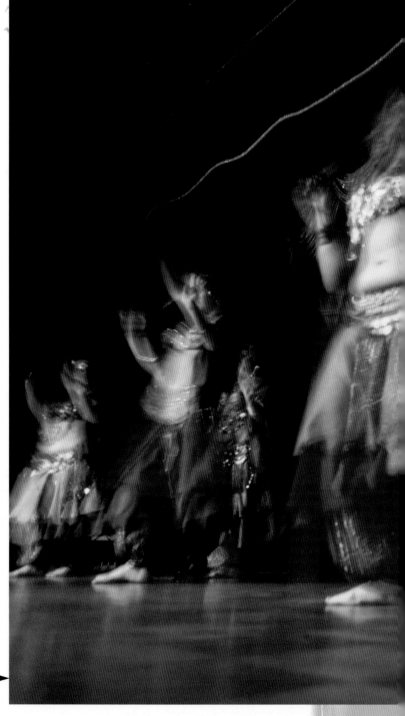

Apertures and shutter speeds are the basic tools that make an exposure possible. But they are also capable of interesting visual effects that don't require special filters or special film.

In this image the low lighting has forced the photographer to use a slow shutter speed. The shutter speed has been too slow to freeze the dancers' movements, and these have recorded as a blur.

Depth of field controls the degree of sharpness in front of and behind the subject. Shallow depth of field means that your main subject is in sharp focus but that the area immediately in front of and behind it is not sharp.

Excessive or greater depth of field means that a larger area in front or behind your subject and of course your subject itself is in sharp focus.

The depth of field in your image depends on the aperture that's used. A wider or larger aperture – f2.8, f4, or f5.6 – will produce shallow depth of field. A smaller aperture – f8, f16 and f22 – will result in greater depth of field.

Shallow depth of field is often used to lose or reduce the impact of a distracting background or foreground in your shot. Common subject areas are portraits and action photography.

Greater depth of field is needed for subjects where a lot of foreground and background details have to be in sharp focus. Common subject areas are landscapes and

Technical Details
35mm SLR camera with a 50mm normal lens and Fujichrome 100.

Understanding Exposure

An SLR's sensitive metering and exposure system have perfectly captured the low lighting and moody colours of this seascape.
The object of exposure meters is to accurately record the lighting in a scene or of a subject as it was. Exposure metering systems in today's cameras are so sensitive that even the most subtle of lighting conditions can be sensed and photographed.

An Exposure Meter, whether inside the camera or used as a separate accessory, measures the light that you are going to use for your photography.
The range of lighting that an exposure meter can read depends on the film speed that has been used as the basis. A sensitive or fast film will give an exposure meter a wider range of lighting to consider rather than a less sensitive or slow film. Exposure meters only take readings from parts of the scene or subject that the exposure sensor (and therefore the camera) is pointing at, so they only give a suggested exposure for that part of your image. In most general lighting conditions this exposure reading should produce an acceptable properly exposed photograph. But in some situations when the subject or the scene has a lot of very dark and very light areas the standard exposure reading method is unable to cope. If it takes an exposure reading from say a light area that is part of a dark scene the resulting image will not be accurately exposed.

To get around this problem it's necessary to adjust the standard correct reading as suggested by the exposure meter. Depending on the lighting conditions you may increase or decrease the basic exposure reading in order to get an accurately exposed image.
Subjects that can 'fool' an exposure meter are those that contain an extreme range of light and dark areas, such as images with sand, snow, bright light, extreme shadow and dark skies.

The exposure meter in some mid to high level cameras are sophisticated enough to be able to take readings from several parts or tones of the subject. It then works out an average exposure reading based on these calculations.

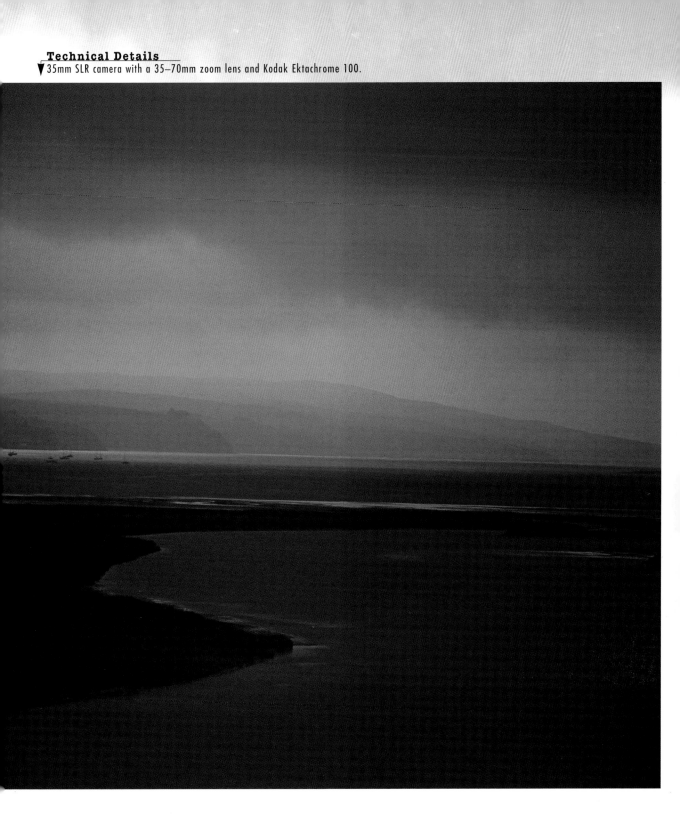

Understanding Exposure

The boat, the stillness of the water and the harmonious colours create **an image** of tranquillity. This subject was photographed just **after sunset.** The calm setting gave the photographer an opportunity to take several shots at progressively slower shutter speeds. The f/stop remained the same throughout while the shutter speed was doubled at each stage. Time was also allowed for Reciprocity Law Failure and the resulting shoot lasted for a duration of 15 minutes.

Notice how decreasing the shutter speed has effected a graduation of colours from dark to light, culminating in the final image on the right, which had a one minute exposure.

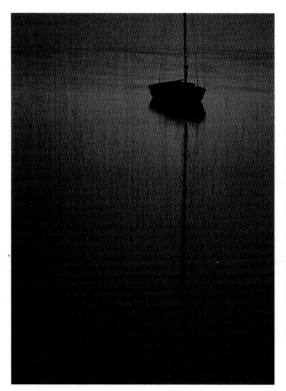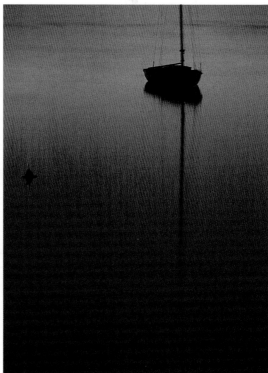

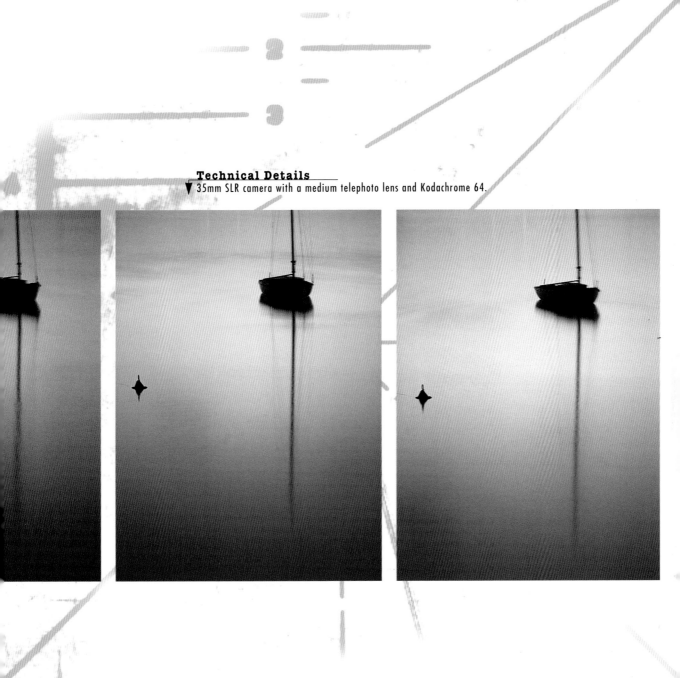

Technical Details

▼ 35mm SLR camera with a medium telephoto lens and Kodachrome 64.

Black and white images taken in low light have plenty of potential for mood and atmosphere, without the distraction of colour.

Fast film has extended the range of subjects available to photographers. In situations that previously demanded use of flash, images can be recorded that accurately capture the lighting situation and mood of a subject or scene.

Technical Details
35mm compact camera and Ilford HP5 b&w film rated at ISO 800. ▼

The main illumination for this shot came from a window to the
right, and the lighting has been enhanced by placing a reflector
on the floor in front of the model.

Technical Details
6x6cm camera with an 80mm lens and an 8mm extention tube, ISO 400 black and white film. ▼

Finishing & Presentation

For your photographs to be seen at their best
they need to be finished and presented in the
most effective way. The method you use in presenting will depend on
whether your images are slides or prints.

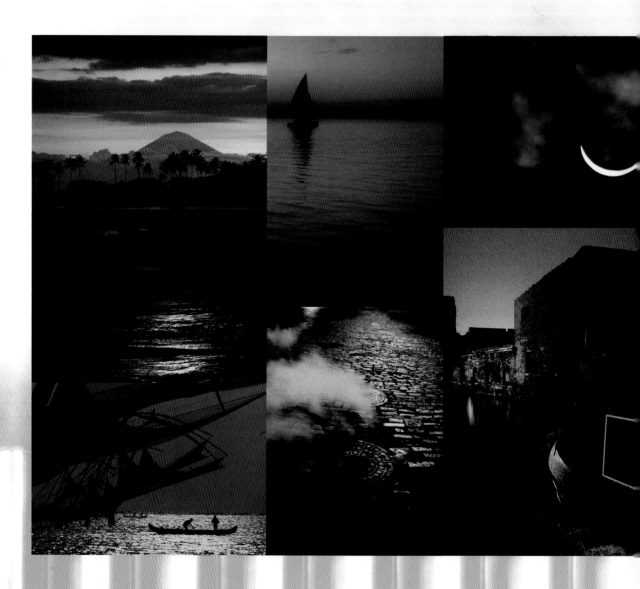

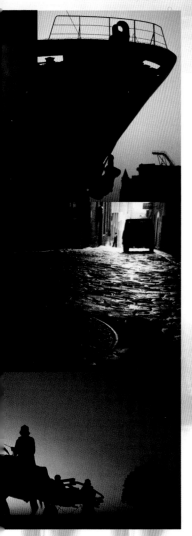

Several strong images can be displayed together as a composite picture or montage.

There are a number of ways to finish and display your images, depending on whether they are slides or prints. Slides can be stored and displayed using plastic sleeves. These slides can be placed in card or hard plastic mounts or they can be removed. The mounted slides can be stored in see-through plastic sheets for display or for use on a lightbox or storage. Slides can also be projected, and special slide mounts with glass windows are made for this.

Slides can also be used to make colour prints. There are special black and white mounts that have cut-out areas to display one or several slides in an attractive way.

Prints can be mounted on the same size frameless mounts made of either wood or other material. There are a number of frames or frame types that can be used to mount a print on. These can be made of wood, plastic and metal. Prints can also be laminated and placed in portfolio cases for frequent viewing. Special card mounts are available (or can be created) for displaying prints for exhibition purposes.

Glossary

AF assist
A feature of a flash gun that projects a beam, thereby enabling an autofocus system to recognise and lock onto its subject, to achieve a sharply focused image. It's a useful feature when photographing in low light. Autofocus systems use contrast as a basis on which to focus, and the image projected by the AF assist flash is a high-contrast pattern that is a perfect target.

AE lock
Auto-exposure lock is a widely used feature found in automatic exposure cameras. It's used to temporarily memorise a particular exposure setting.

Air release
This is a cable release that is operated by air pumped by a rubber bulb. It produces the same result as a cable release that uses a plunger.

B setting
This is one of the most useful shutter speeds for the lowlight photographer and is found below the slowest shutter speed on the shutter speed dial. Pressing B opens the shutter for as long as the shutter button is pressed, and releasing it immediately closes the shutter. It's the basis for long night-time exposures and for open flash photography (see below).

Backlight button
A feature that is used to compensate for excessive lighting behind a subject, which would otherwise 'fool' an auto-exposure system into giving an incorrect exposure.

Ball and socket head
An adjustable platform on top of a tripod that is able to freely position and hold the camera in a rigid position.

Beanbag
Dried seeds or beans encased in a small cloth, velvet or plastic bag. Its ability to adjust its shape makes it an ideal steadying support for a camera or lens in the absence of a tripod.

Cable release
A cable with a plunger at one end, and connected to a camera's shutter button that enables it to be controlled from a distance away. There are manual and electronic cable releases and they come in a range of lengths. A bulb release is a cable release which is controlled by air via a manually squeezable rubber bulb.

CdS
Abbreviation for Cadmium Sulphide, a light-sensitive element used in light meters for calculating exposures.

Chestpod
A type of modified camera support that needs to rest against the chest for steadying purposes. Some types have a rifle butt type of support base.

Compensating filters (for colour correction for long exposures)
Special coloured filters that are used to compensate for colour shifts that can occur when using film for very long exposures or under artificial lighting.

Dedicated flash
A flashgun with exposure and performance features that are compatible with a specific camera brand or range.

Dioptre correction
A feature found in some camera viewfinders that enables the optical focus of the viewfinder to be adjusted to suit spectacle wearers.

Exposure latitude
The extent of under- or overexposure of which a film is capable that will still provide an acceptable image. Slide films tend to have a narrow exposure latitude with a working range of around + or -1 stop either side of the correct exposure setting. Colour print films tend to have a wider exposure latitude, typically providing acceptable images at up to + or -2 stops of exposure.

Evaluative flash metering
A dedicated flash gun that is able to provide a flash exposure based on the readings supplied by a camera's evaluative metering system.

Evaluative metering
An SLR metering method that provides an exposure based on meter readings taken from various parts of a scene and then calculated to give an averaged reading.

Exposure bracketing
Taking several shots of the same subject but at different exposure settings above as well as below the correct exposure setting. This is to give the photographer a range of options to choose from as the so-called 'correct' exposure setting may not always be as effective with certain subjects or lighting situations. Some high-end SLRs have auto-exposure bracketing that allows the user to set the camera to automatically take a series of shots at pre-selected settings.

Exposure Value (EV)
Any aperture and shutter speed setting that is able to provide a correct exposure. A selection of these is called the EV range and is an indication of the exposure capabilities of a camera or light meter.

Film grain
A characteristic of fast or pushed film is that the texture of the film emulsion becomes more noticeable. This more noticeable texture or film grain is an expected result, and gives a distinctive quality to images.

Flash bracket

An arm that is attachable to a camera and that contains a support for an external flash gun. Some flash brackets can be adjustable so as to increase the distance between them and the camera for more versatile flash illumination.

Flash sync socket

This enables an external flash gun to be connected directly to the camera body (and not necessarily the camera's flash hotshoe) via a cable. It's often used in conjunction with the flash bracket (above).

Flash sync speed

The appropriate shutter speed that synchronises with the flash gun. Depending on the camera in use typical flash sync speeds are 1/30sec, 1/60sec, 1/90sec, 1/125sec or 1/250sec. Note that the flash synchronises with the flash sync speed and any shutter speed slower than it. On an SLR camera using a shutter speed faster than the flash sync speed will cause part of the image to be blacked out, caused by the shutter mechanism unable to work effectively with flash at that speed.

Guide number

The guide number of a flash gun shows its power output. The higher the guide number the more powerful the flash gun. A flash gun with a guide number of 25 used with ISO 100 film, and with an aperture of f/5.6 for example, will be able to give adequate illumination for a subject that is around 4m away.

Hotshoe flash sync adaptor

Some flash sync sockets are found on the camera body, while others are found on special attachable adaptors that fit onto the hotshoe.

Image stabilisers

Some cameras and lenses have special electronic circuitry that is able to sense and subdue accidental movement or shake to produce a blur-free picture.

Mercury vapour

A type of street lighting that looks white in real life but appears as greenish blue when photographed using normal film.

Neutral density filter

Sometimes the light reaching the camera needs to be dramatically reduced, beyond even the limits of the camera's exposure system. For this a neutral density filter is used. This darkens the image seen through the lens without affecting the colours. Neutral density filters come in different strengths and are sometimes necessary for long exposures of bright light source subjects e.g. lightning.

NiCad batteries

NiCad stands for Nickel Cadmium which is a component used in special rechargeable batteries.

Open flash technique

This technique is commonly used for artificially lighting dark and complex interiors with flash. The shutter speed is first set to B, then a series of flashes is fired while the shutter is open.

Reciprocity Law Failure

Reciprocity law failure happens when a film is unable to cope with a range of lighting conditions beyond its capabilities. The results are usually false colours, and lighting variations.

Ringflash

A ringflash is a special flash gun in which the flash is ring-shaped. This is to provide virtually shadow-free lighting and is useful for photography close-ups. It is also used in some portraiture. A telltale sign that a ringflash has been used in an image is the appearance of ring-shaped highlights.

SPD

Silicon Photo Diode, a light-sensitive element used in some light meters.

Selenium

A light-sensitive element used in some light meters. It has been replaced by more sensitive GPD and SPD systems of light-reading.

Slow speed flash sync

With this feature, seen on some high-end cameras, the flash duration is able to correspond to selected slow shutter speeds.

Spot-metering

This is a way to selectively measure light from a small part of a subject. It's used for fine-tuned exposure readings, or to work out an average general reading.

Strobe flash

This special flash unit lets out a rapid succession of powerful but brief flash emissions. It's ideal for capturing fast-moving action subjects, and shows these as a selection of frozen images, all on the same frame of film. N.B. In some countries a normal flash gun is often called a 'strobe'.

Table top tripod

A mini tripod that can support a compact camera or a small SLR. Some mini tripods can be adjusted for use as chestpods.

Tripod clamp

A powerful clamp with a tripod platform, able to be clamped onto rigid objects such as railings or fences.

Warming filters

Filters that provide warmer i.e. yellow or orange colouring to an image. Often used to neutralise the cool blue effects of some types of daylight i.e. early morning.

PhotoDisc Europe Ltd

PhotoDisc Europe Ltd
Regal House
70 London Road
Twickenham
Middlesex
TW1 3QS
Tel: 0181 255 2900
Fax: 0181 255 2930
Web: www.photodisc.com/uk

Contact: Sales and Customer Support:
0845 302 1212

Email: sales@photodisc.co.uk

Royalty-free, high-resolution stock photography.

PhotoDisc, the market leading royalty-free stock photography brand of Getty Images, Inc. (NASDAQ: GETY), was one of the first publishers of high-resolution digital stock photography. The PhotoDisc image library consists of approximately 75,000 royalty-free images, of which more than 30,000 are available on more than 160 thematic CD-ROM collections. Individual images and CD-ROMs are available worldwide for purchase in file sizes up to 28MB from the award-winning PhotoDisc website http://www.photodisc.com/uk. PhotoDisc has been providing images to creative professionals in industries including graphic design, advertising, prepress, publishing, and web and multimedia design since its founding in 1991.

PhotoDisc and the PhotoDisc website have won more than 10 international awards for online commerce. Customers can search quickly and efficiently through the 75,000-strong image collection, create online lightboxes to store images and purchase and download the images they need 24 hours a day, 7 days a week.